Wildlife
Photographer
of the Year
Portfolio 23

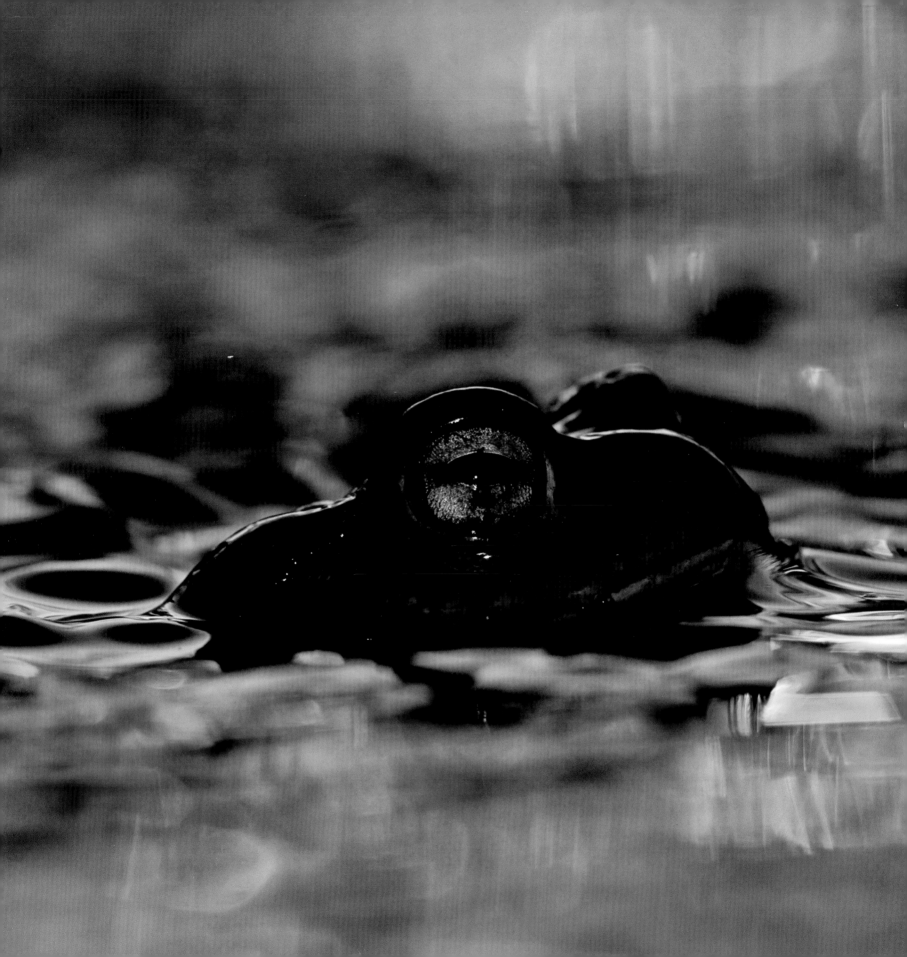

Wildlife Photographer of the Year

Portfolio 23

Published by the Natural History Museum, London

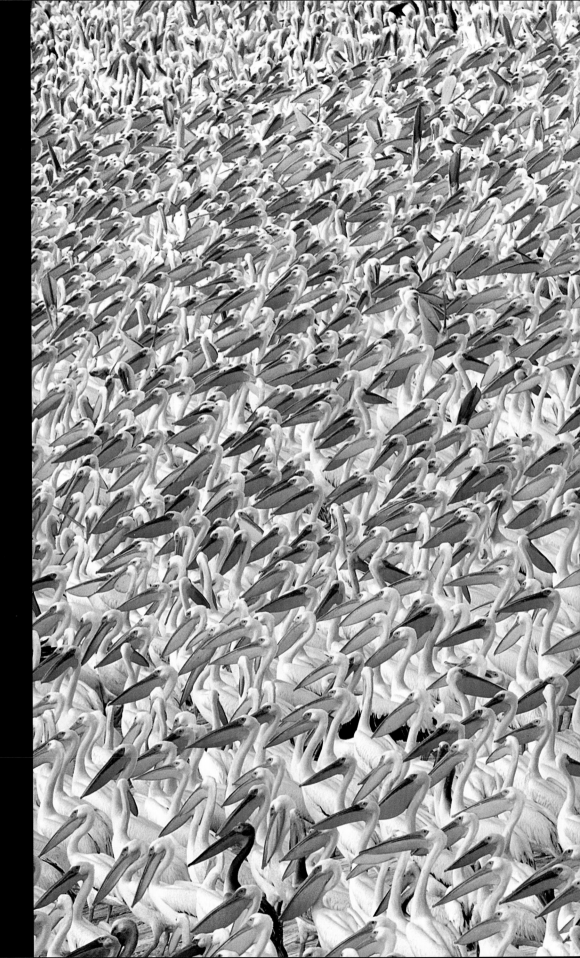

First published by the Natural History Museum,
Cromwell Road, London SW7 5BD
© Natural History Museum, London, 2013
Photography © the individual photographers 2013

ISBN 978-0565-09331-0

A catalogue record for this book is available from the
British Library.

Editor: Rosamund Kidman Cox
Designer: Bobby Birchall, Bobby&Co Design
Caption writers: Rachel Ashton and Tamsin Constable
Colour reproduction: Saxon Digital Services UK
Printing: Printer Trento Srl, Italy

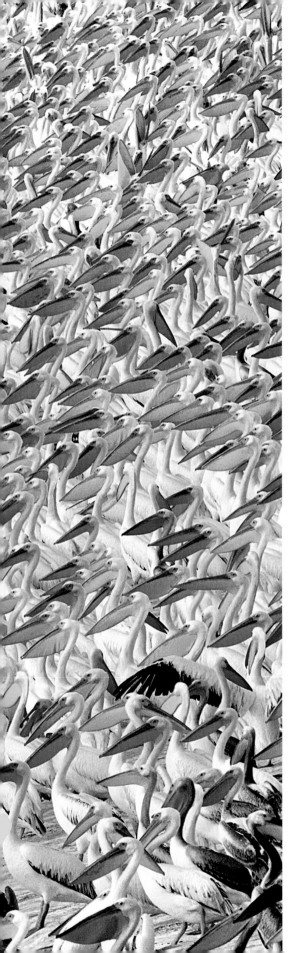

Contents

Foreword

Before writing this foreword I again reviewed each of the winning 100 photographs that are included in this book – from the nearly 43,000 entered. I thought about how to describe in words the subject of each image. Add to those words the emotions each inspires, and there wouldn't be room on the page. Forget the cliché 'a picture is worth a thousand words'. It's virtually impossible to use words accurately to describe the meaning and emotional impact of a good photograph.

You only needed to sit in this year's judging room to see first-hand the frustration of seasoned professional photographers and editors struggling to come up with adequate words to describe why they liked a particular image on the screen. It can be almost awkward at times: 'I don't know why – I just like the feeling I get from it,' judges repeat many times in the sessions. We can never have enough descriptive language to sort out the winners and make a convincing argument for the photographs that are special to us. It's difficult to find convincing language in normal circumstances. The photographs only need to speak for themselves. They are their own language. That's why and how many of us got started with a camera. The frustrations brought by the limits of language were my driving force when I first picked up a camera.

Consider the photograph on page 109 of the elephants tightly grouped in an empty landscape during a dramatic sandstorm. I well remember how an audible gasp was heard in the room when it first appeared on screen. Some were instantly and deeply moved. Then, when discussing the final winners, there was an almost startling difference of opinion. I listened carefully to the argument. The image simply did not appeal to one highly regarded professional, no matter what the others said. Of course, the emotional response to a photograph can be the result of

our cultural aesthetics and our own past experiences, even of landscape and light. And it takes a very skilled person to articulate exactly why a picture resonates with him or her.

Some people, though, even visual professionals, rely heavily on their vocabulary to drive their appraisals. In their eyes, if you can't explain the aesthetic, it loses value. But sometimes descriptions of a picture are more about the art of writing than about painting or photography. Then the words can become more important than the art – even become an art form in themselves when language is used to justify a work of 'art'. We all have seen extreme examples of this. Intellectual arguments – words – have their own kind of power.

But whether the power of a single image can be explained in words or not, its emotional effect remains powerful. The award-winning image of the ghostly elephants seemed to hit that magical sweet spot – all in the judging room agreed that it 'spoke'. Yet when I tried to write an evaluation of the picture and describe why it rose to the top, I had quite a difficult time. I could not quite find adequate words – especially in one short hit – to describe the feeling the image provoked in me. It's no surprise that words and visual expressions, especially photographs, are simply separate ways of communicating, and they often might communicate quite separate outlooks on life – untranslatable to each other. It's also possible that pictures are the more natural of the two. After all, humankind's first pictures date back more than 35,000 years before the first writing.

JIM BRANDENBURG
Chair of the judges, Wildlife Photographer of the Year 2013

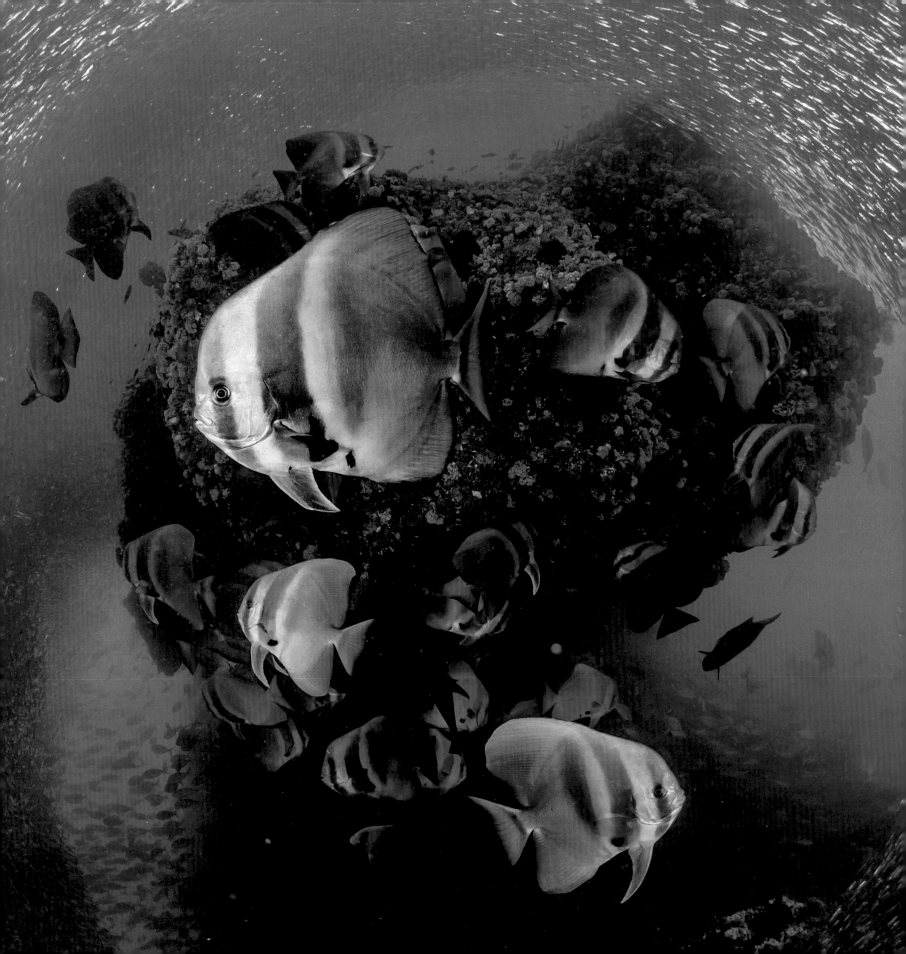

The Competition

On the pages that follow you will see the 100 very best pictures of wildlife and the natural environment entered by photographers worldwide for the 2013 Wildlife Photographer of the Year competition. It's an international event with an international jury, and this year the pictures were selected from nearly 43,000 entries, representing more than 96 countries. It's also a collection of photographic art, representing different ways of seeing the natural world, from documentary and portraiture to commentary and reflections on the beauty and importance of nature.

Still images, by their unforgettable singularity, can be more powerful than moving ones. Through this collection of single, unforgettable pictures, the competition aims to make its audience both wonder at the splendour, drama and variety of life on Earth and become more aware of human pressures on the natural world.

There are different categories – a way of encompassing the great range of natural subject matter and genres of nature photography – but all the pictures are judged first on their aesthetic qualities. There are, however, restrictions on the manipulation of both animals and the pictures themselves. Wild animals have to be in the wild (except where illustrating an issue in specific categories) and photographed without distress being caused to them. No manipulation of photographs is allowed beyond in-camera settings and digital processing according to strict rules. That means that the pictures you see here are truthful reflections of nature and that the artistry is in the original capture.

The competition represents a long collaboration between *BBC Wildlife* Magazine and the Natural History Museum, London. It also has a long history, with the very first competition launched back in 1965, at a time when colour photography had become affordable and conservation was in the public consciousness. Past winners include many of the big names in the world of wildlife photography today.

Through a major exhibition that travels the world and the associated international media coverage, the collection will be seen by many millions of people. With the aim of displaying the range of styles, techniques and cultural ways of seeing the natural world, this is a collection that has the power to inspire photographers in different countries to produce fresh, innovative work. Not only does it celebrate the natural world but by giving exposure to powerful pictures it also raises awareness and effects change.

Many of the winners are professionals, but the rollcall also includes semi-professionals and amateurs, some of whom will become tomorrow's professionals. Indeed, one of the competition's aims is to encourage the next generation of photographic artists. It does this both through the Young Wildlife Photographer of the Year competition and the Eric Hosking Portfolio Award, which rewards photographers early in their careers – financially but also through the mentoring, and the publicity and prestige that comes with winning an award in this competition, the biggest and most respected of its kind in the world.

The call for entries opens each year from December to February. Find out more about contributing to the Wildlife Photographer of the Year legacy of images at www.wildlifephotographeroftheyear.com

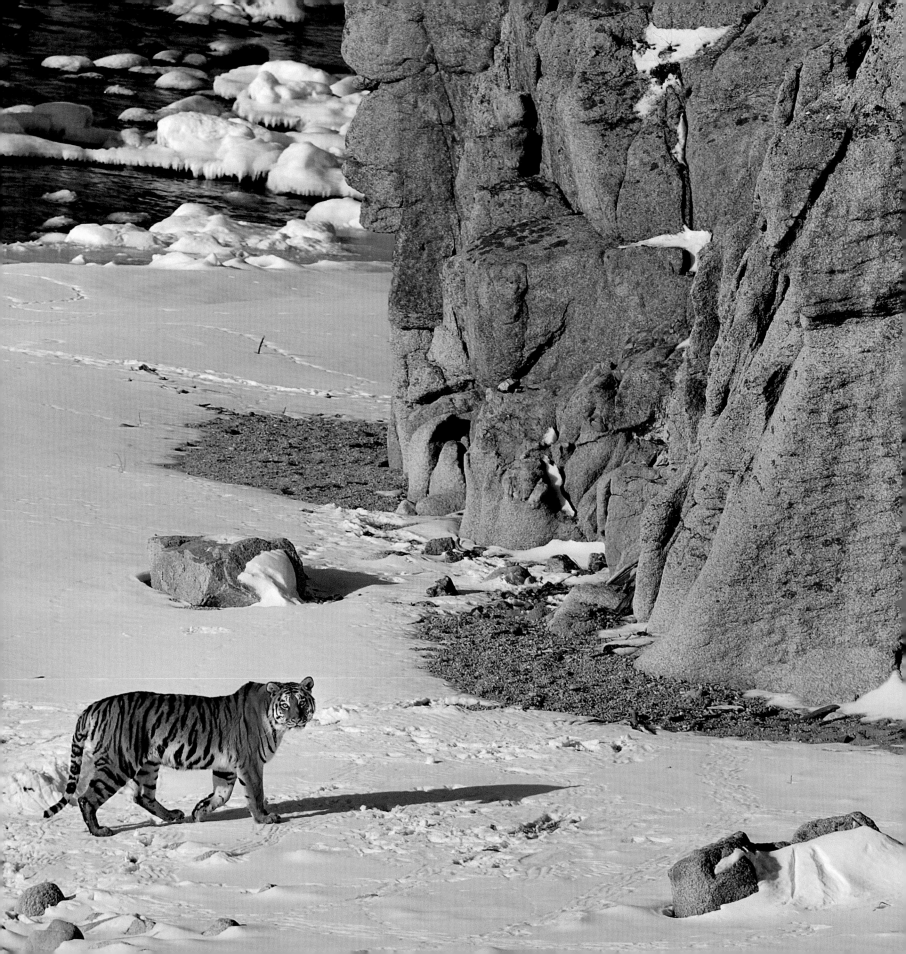

The Organiser

Wildlife Photographer of the Year is one of the Museum's most successful and long-running events. Together with *BBC Wildlife* Magazine, the Museum has made it the most prestigious, innovative photographic competition of its kind and an international leader in the artistic representation of the natural world.

The annual exhibition of award-winning images continues to raise the bar of wildlife photography and excite its loyal fans, as well as a growing new audience. People come to the Museum and tour venues across the UK and around the world to see the photographs and gain an insight into the diversity of the natural world – an issue at the heart of our work.

Open to visitors since 1881, the Natural History Museum looks after a world-class collection of 70 million specimens. It is also a leading scientific-research institution, with groundbreaking projects in more than 70 countries. About 300 scientists work at the Museum, researching the valuable collection to better understand life on Earth, its ecosystems and the threats it faces.

Last year, more than four million visitors were welcomed through the Museum's doors to enjoy the many galleries and exhibitions that celebrate the beauty and meaning of the natural world, encouraging us to see the environment around us with new eyes.

Visit www.nhm.ac.uk for what's on at the Museum.
You can also call +44 (0)20 7942 5000
email information@nhm.ac.uk
or write to us at:
Information Enquiries
Natural History Museum
Cromwell Road
London SW7 5BD

The Magazine Partner

The images that grace the magazine's pages – spectacular, intimate, powerful, thought-provoking and moving – represent the very best of wildlife photography.

BBC Wildlife Magazine is proud to have launched the forerunner of this competition in the1960s and to have nurtured its development into a showcase for the brightest talents in natural-history photography.

The same love of wildlife and wonder at the natural world inspire the magazine.

Every month, *BBC Wildlife* showcases beautiful images, compelling stories and fascinating facts. Covering everything from animal behaviour to British wildlife, the latest conservation issues to inspirational adventures, our writers are all experts in their fields.

Our award-winning features are illustrated with the world's finest photography – images captured by photographers recognised in this competition.

We publish all of the winning images from the Wildlife Photographer of the Year competition in our glossy and gorgeous guide, free with the November issue.

Visit www.discoverwildlife.com to subscribe to *BBC Wildlife*, read amazing articles and enjoy stunning photo galleries.
You can also call +44 (0)117 927 9009
or email wildlifemagazine@immediate.co.uk

The Judges

Ingo Arndt
wildlife photographer (Germany)

Sophie Boulet-Gercourt
executive, Biosphoto (France)

Luciano Candisani
wildlife photojournalist (Brazil)

Tui De Roy
naturalist, wildlife photographer
(New Zealand)

Richard Eccleston
Art Editor, *BBC Wildlife* Magazine (UK)

Ruth Eichhorn
Director of Photography, *GEO* Magazine
(Germany)

Lisa Lytton
Director, Paraculture Books, Director of Digital
Editions, *National Geographic* Magazine (US)

Koji Nakamura
underwater photographer,
President, Japan Underwater Films (Japan)

Elio Lello Piazza
natural history picture editor (Italy)

Anna Sever
director, picture editor, ASA Agency (Spain)

Igor Shpilenok,
wildlife photographer (Russia)

Hans Strand
landscape photographer (Sweden)

Jan Vermeer
wildlife photographer (The Netherlands)

Chair of the judges

Jim Brandenburg
photographer (USA)

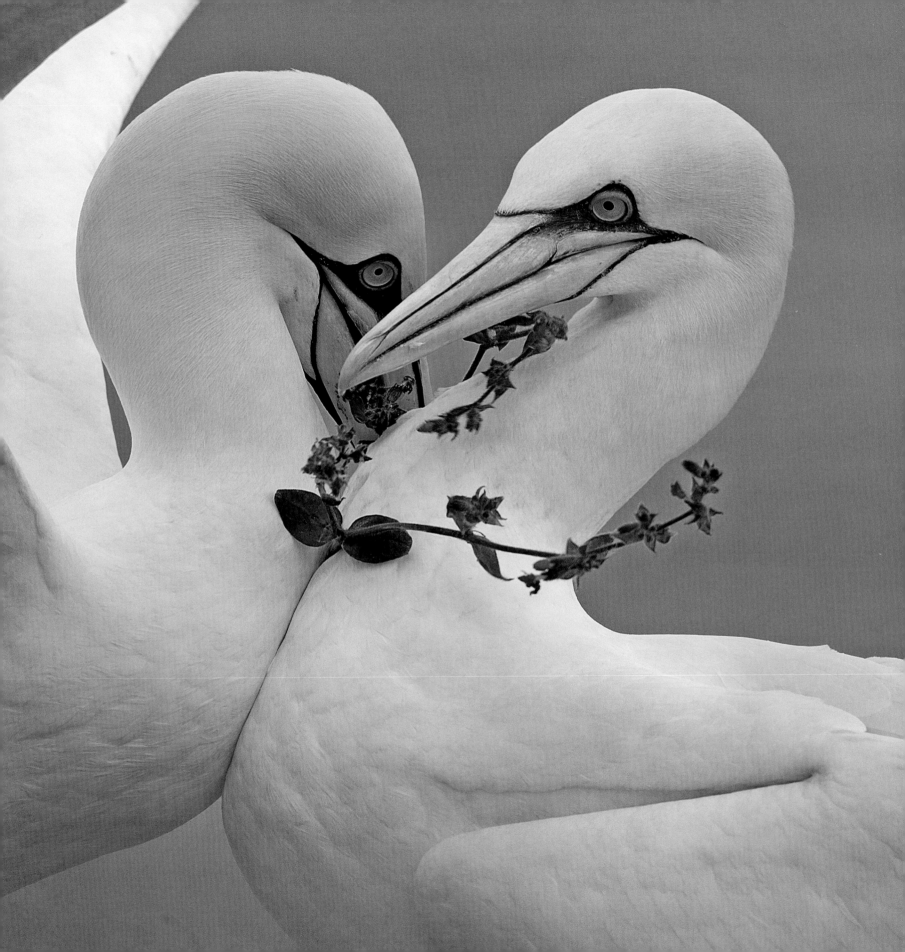

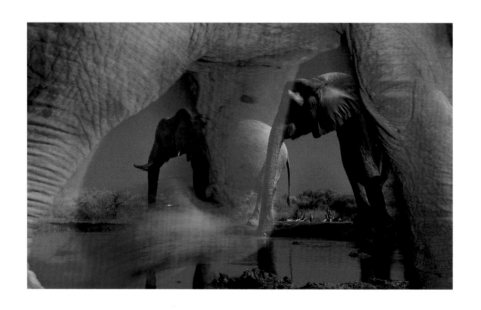

The Wildlife Photographer of the Year 2013

The Wildlife Photographer of the Year 2013 is **Greg du Toit**, whose picture has been chosen as the most striking and memorable of all the entries in the competition.

Greg du Toit

Greg is a professional wildlife photographer, who has lived and worked in four different African countries. Born in South Africa, he was passionate about wildlife from a young age, and after studying nature conservation, he worked as a wilderness guide in South Africa's Timbavati Game Reserve. His days spent stalking animals proved invaluable when he became a professional wildlife photographer, and over the past 12 years, he has worked in some of Africa's wildest and remotest ecosystems. Greg's pictures have been exhibited from New York to Singapore and profiled in international magazines. His first book on African wildlife has just been published.

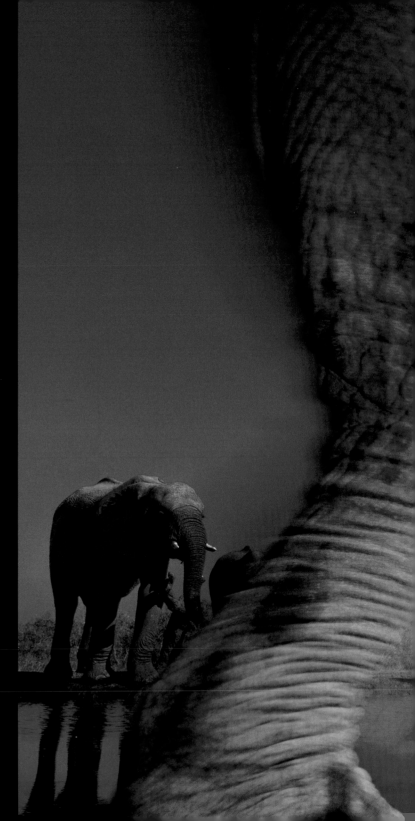

Essence of elephants

Greg du Toit

SOUTH AFRICA (SEE PREVIOUS PAGE)

Ever since he first picked up a camera, Greg has photographed African elephants. 'For many years,' he says, 'I've wanted to create an image that captures their special energy and the state of consciousness that I sense when I'm with them. This image comes closest to doing that.' The shot was taken at a waterhole in Botswana's Northern Tuli Game Reserve, from a hide (a sunken freight container) that provided a ground-level view. Greg chose to use a slow shutter speed to create the atmosphere he was after and try 'to depict these gentle giants in an almost ghostly way'. He used a wide-angle lens tilted up to emphasise the size of whatever elephant entered the foreground, and chose a narrow aperture to create a large depth of field so that any elephants in the background would also be in focus. Greg had hoped the elephants would turn up before dawn, but they arrived after the sun was up. To emphasise the 'mysterious nature' of these enigmatic subjects', he attached a polarising filter and set his white balance to a cool temperature. The element of luck that added the final touch to his preparation was the baby elephant, which raced past the hide, so close that Greg could have touched her. The slow shutter speed conveyed the motion, and a short burst of flash at the end of the exposure froze a fleeting bit of detail.

Nikon D3s + 16-35mm f4 lens + polarising filter; 1/30 sec at f22; ISO 800; Nikon SB-900 flash + SC28 remote cord; mini-tripod; Nikon cable-release

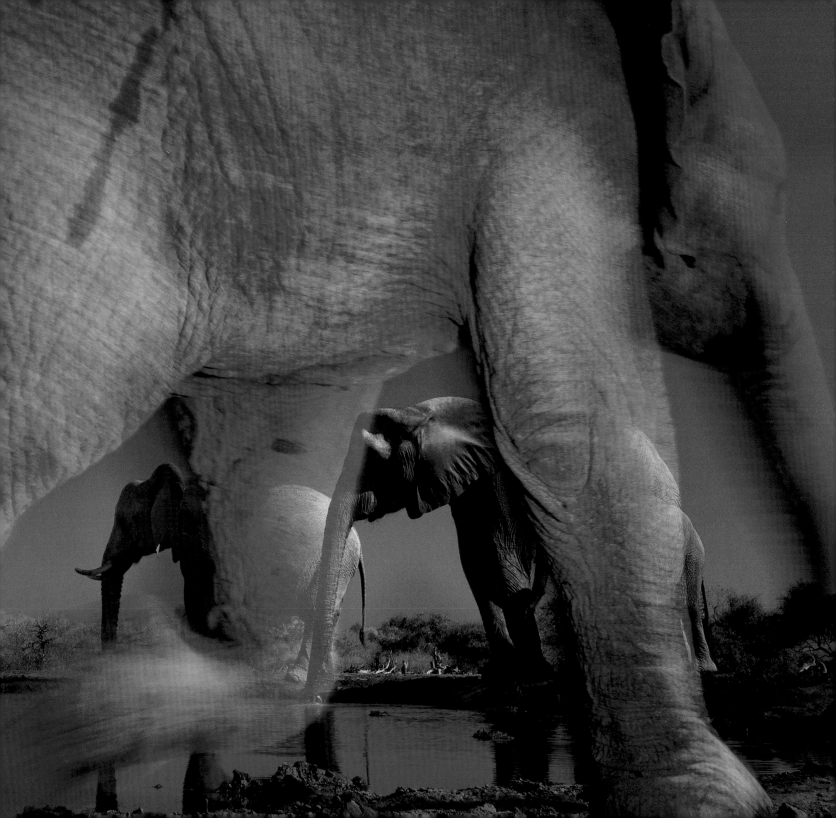

Showdown

Peter Delaney

IRELAND/SOUTH AFRICA

It was midday, and Peter had arrived at a
waterhole in the Kgalagadi Transfrontier Park, South
Africa. Scores of white-backed and lappet-faced
vultures covered an eland carcass, squabbling over
the meat. 'Two things hit me simultaneously,' says
Peter. 'The vile stench of rotting flesh and the
intense buzz of flies.' The white-backed vultures
were surprisingly violent as they vied for the
best feeding positions. This particular individual
had backed off from a fight but was about to
re-enter the fray. Covered in dust, wings spread,
head lowered, it reminded Peter of a gladiator in
his chariot, lining up for a charge. Its picture is a
portrayal of the true character of this feisty bird.

Nikon D2Xs + 200-400mm f4 lens + 1.4x teleconverter;
1/1250 sec at f9; ISO 400; window mount; Gimbal head.

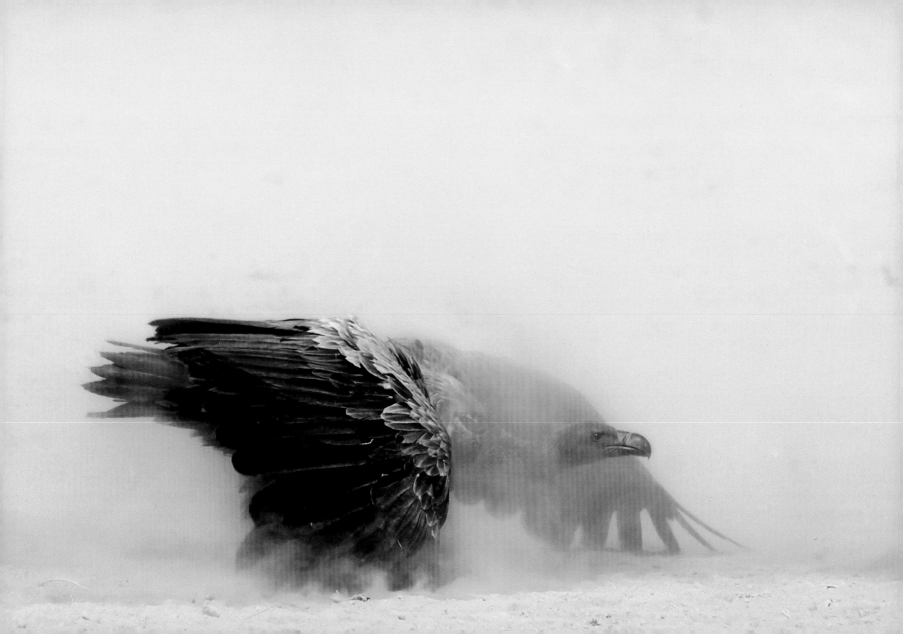

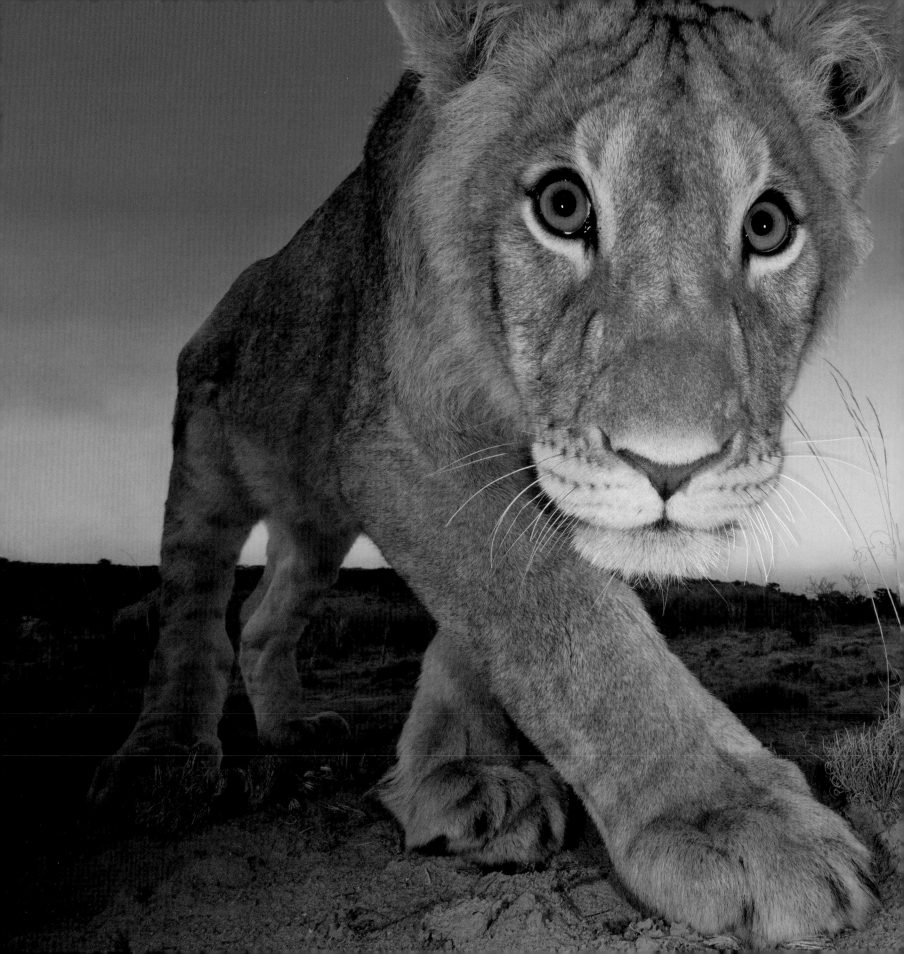

Curiosity and the cat

JOINT RUNNER-UP

Hannes Lochner

SOUTH AFRICA

Hannes has spent nearly five years perfecting his remote wireless technology to photograph intimate portraits of wild African animals, by night especially. In the Kgalagadi Transfrontier Park in the Kalahari, South Africa, he set up one camera near a waterhole, hiding it from lions especially, which might play with it or carry it off. On this particular evening, he was settled in his vehicle, just as the sun was setting and the dust in the air creates a special kind of Kalahari light, when a pride of lions arrived. By repeatedly clicking the shutter, he coaxed the ever-curious cubs forward. This bold individual gazed into the camera lens as it stepped forwards to sniff the strange object. 'All the camera settings were on manual,' explains Hannes, 'and I had pre-focused. So I could do no more than hope I had judged the lighting and angle correctly.' He had done so, capturing the intimate portrait and the eye-contact he was after.

Nikon D3 + 16-35mm f4 lens; 1/60 sec at f16; ISO 3200; Nikon R1C1 strobe; Pocket Wizard wireless remote.

Travelling companions

COMMENDED

Douglas Seifert

USA

Swimming in front of this dugong in the Red Sea are juvenile golden trevallies, riding the pressure waves created by its nose. They use the great mammal as protection from predators and also feed on any small creatures it disturbs. The dugong is a tranquil animal, and it used to be an easy target for hunters – its closest modern relative, Steller's sea cow, was hunted to extinction in the eighteenth century. These days, it's more at risk from the loss of its seagrass habitat and from encounters with boats and fishing nets. Though dugongs are slow-moving, this simple portrait required a certain amount of physical exertion, as Douglas, wearing full scuba gear, had to position himself ahead of the dugong, while not letting bubbles spoil the simple scene or scare the animal. 'I had pre-conceived this image,' says Douglas, 'and knew when the shutter clicked that I'd captured the intimate portrait I was after.'

Canon EOS 5D Mark II + 16-35mm f2.8 lens; 1/200 sec at f11; ISO 640; Seacam housing; two INON z-220 strobes.

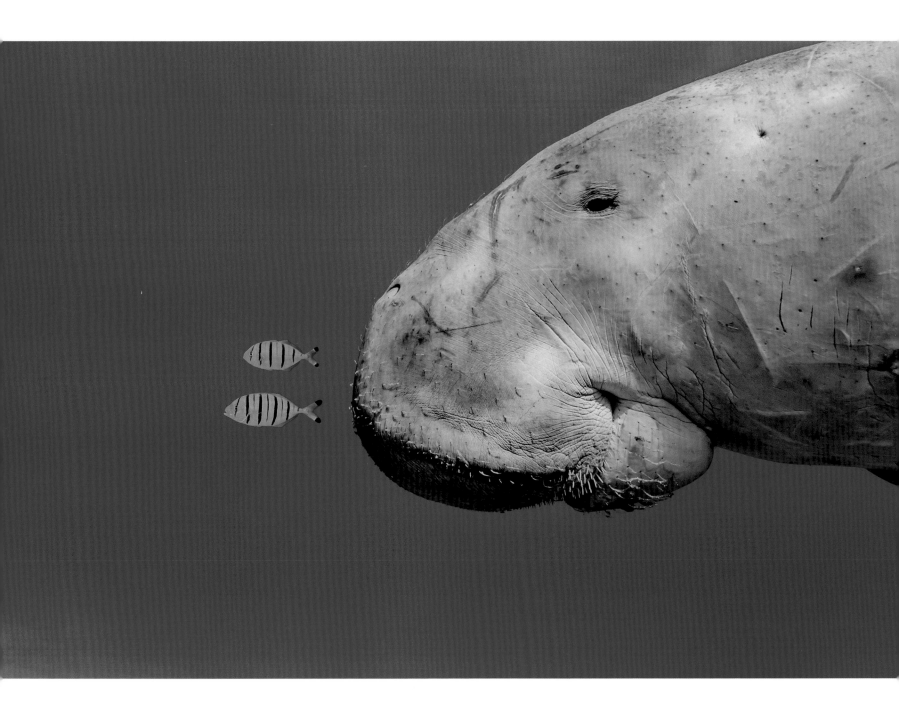

Eye of a toad

COMMENDED

Łukasz Bożycki

POLAND

Early spring sees a pond near Łukasz's home city of Warsaw, Poland, full of mating frogs and a few toads. On this March day, Łukasz shared the pond with them for an evening, sitting in the icy water in his chest-high waders, keeping as still as possible, despite the numbing cold, so that the amphibians could get used to him. 'I wanted to find a fresh way of portraying the amphibians,' he says, 'at water level.' Using a telephoto lens, he focused on one lone toad and waited for the sun to dip almost below the horizon before pressing the shutter, using flash to bring out the details in the shadow. His prize was 'the glorious pool of sunset colour' and fiery glow of the toad's eye.

Nikon D80 + 70-300mm f4.5-5.6 lens + extension tube; 1/125 sec at f9 (-2.3 e/v); ISO 100; built-in flash.

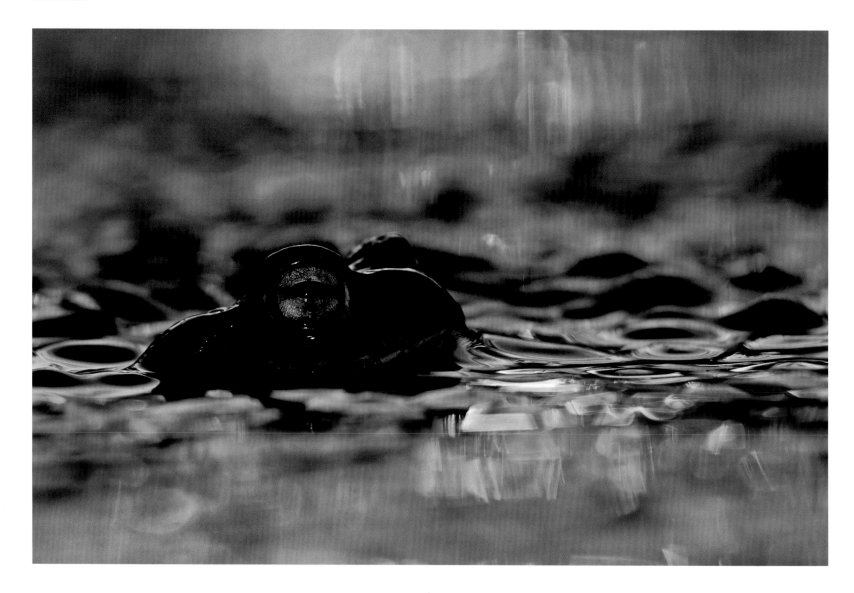

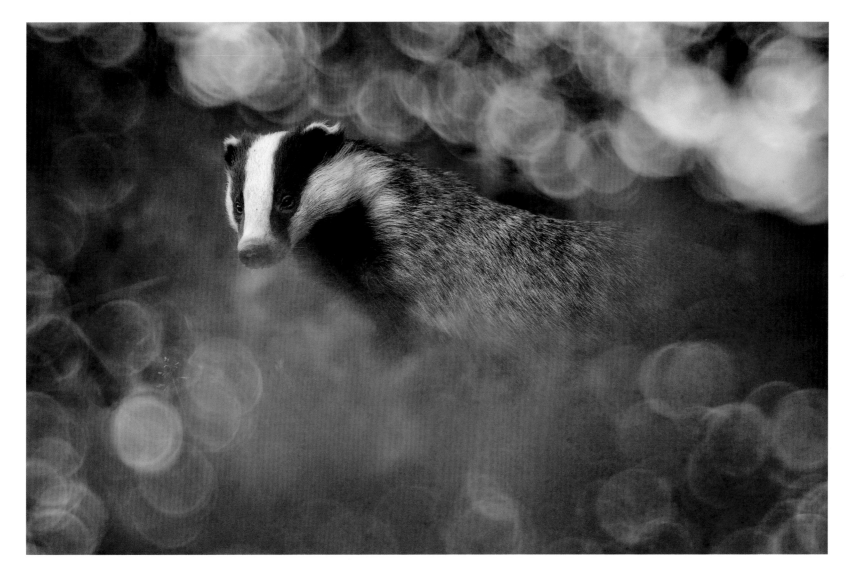

Badger dream scene

COMMENDED

Marc Steichen

LUXEMBOURG

Every May and June for the past five years, Marc has been photographing badgers at a sett near his home town in Luxembourg. On this early summer evening, the light was fading fast as the first badger emerged from its den to check its surroundings. 'I wanted to photograph the badger exactly as I saw it,' says Marc, 'with the setting sun as a backdrop,' and he had positioned himself with this in mind. It was always a gamble whether a badger would emerge in time to catch the light, but on this day it did. To capture the warm apricot sun-flare, he made a double exposure, first focusing on the badger and then defocusing to take a softer image, 'creating as dreamy a scene as it was that evening'.

Canon EOS 5D Mark III + 300mm f2.8 lens + Meyer Gorlitz Trioplan 100mm f2.8 lens; 1/250 sec at f2.8; ISO 400; in-camera multiple exposure.

The President's crown

WINNER

Michael 'Nick' Nichols

USA

Nick's goal was to create an image that would pay homage to the grandeur of the President. This giant sequoia, 3,200 years old and growing ever larger in California's Sequoia National Park, is not the tallest tree on Earth. Nor is it the widest or the bulkiest. Its trunk, though a massive eight metres in diameter, is smaller than that of the largest tree, the General Sherman redwood. But the President has a crown larger than the Sherman's and carries a load of some two billion leaves, more than any other tree. On top of that, for seven months of the year, it carries a huge weight of snow. What Nick aimed to do was show the tree as it couldn't possibly be seen from the ground, where 'you have no idea of the majesty.' To photograph the breadth and height of this giant involved a complicated pulley system rigged up in a neighbouring giant, three cameras, pictures taken in tandem at set intervals from top to bottom, and a complex computer exercise stitching together the final mosaic of 126 images. What makes the red figure at the top seem taller than the one at the bottom is the fact that he's standing forward on one of the tree's mighty limbs. 'I chose to shoot it in February, praying for big snowflakes,' says Nick. 'And that's exactly what nature gave us, plus 10 feet of fresh snow. When people see the tree in its totality, they get it – they gasp.'

Three Canon EOS 1Ds Mark III + three 35mm f1.4 lenses; 1/350-1/1000 sec; ISO 200.

Cocoon of life

COMMENDED

Kalyan Varma

INDIA

Veins reach across the wings and around the embryo of the seed of the Andaman redwood. Kalyan had searched through the leaf-litter beneath some of these magnificent trees to find the perfect seed. 'They are only slightly larger than a coin and very delicate,' he says. 'It took me a while to find one that was not torn, crushed or old.' It is, he says, difficult to do justice to the grandeur of these trees – also known as East India mahogany and found only on the Andaman Islands of India – and to the amazing engineering and design of their wind-dispersed seeds. He wants people to pause and puzzle over what they are looking at. 'It could, at first glance, be the roots of some strange organism, or the veins of part of an animal or a leaf,' he says. 'I want people to slowly realise what it is and marvel at the intricacies of nature.'

Nikon D700 + 105mm f2.8 lens + flash diffuser; 1/60 sec at f16; ISO 400; Nikon SB-800 flash.

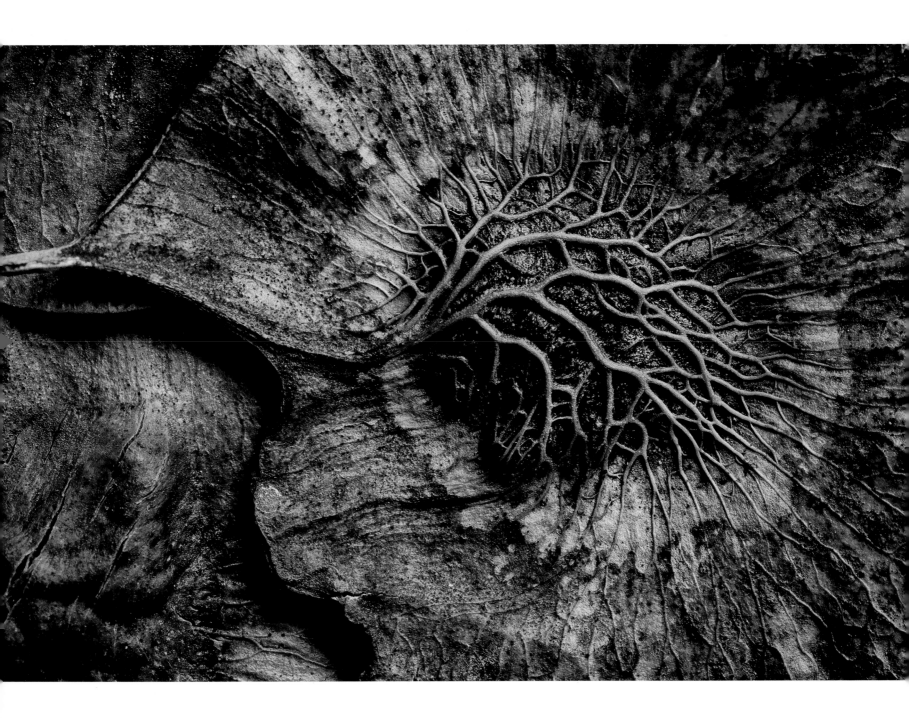

The magical kokerbooms

COMMENDED

Uge Fuertes Sanz

SPAIN

When he clinched the frame, at the final moment
of sunset, Uge was ecstatic. 'I felt this was possibly
the most beautiful picture I'd ever created.' He had
set up camp in the Giant's Playground in Namibia
specifically to photograph the dramatic landscape
at night. And as the African night descended,
he felt the enchantment of the place. It wasn't
just the dramatic dolerite boulders, strewn about
like a giant's toys. It was also the otherworldly,
'magical' kokerbooms, or quiver trees. These are
giant succulents, aloes, found only in Namibia
and part of South Africa, which survive the arid
conditions by storing large amounts of water in
their trunks and leaves. He staged the fairytale
set, just as the sun went down, by lighting specific
trees at specific distances with a torch, using a
long exposure and adjusting the zoom to highlight
the changing colours as the natural light faded,
moving the torch from tree to tree. He had very
little time, and had just three chances at the
composition. The crowning element was the
spread of branches overhead, 'closing the frame
and giving the picture its strength'.

**Canon 7D + Tokina 12-24mm f4 lens; 95 sec at f4;
ISO 320; Manfrotto tripod; Tank007 TK-737 torch.**

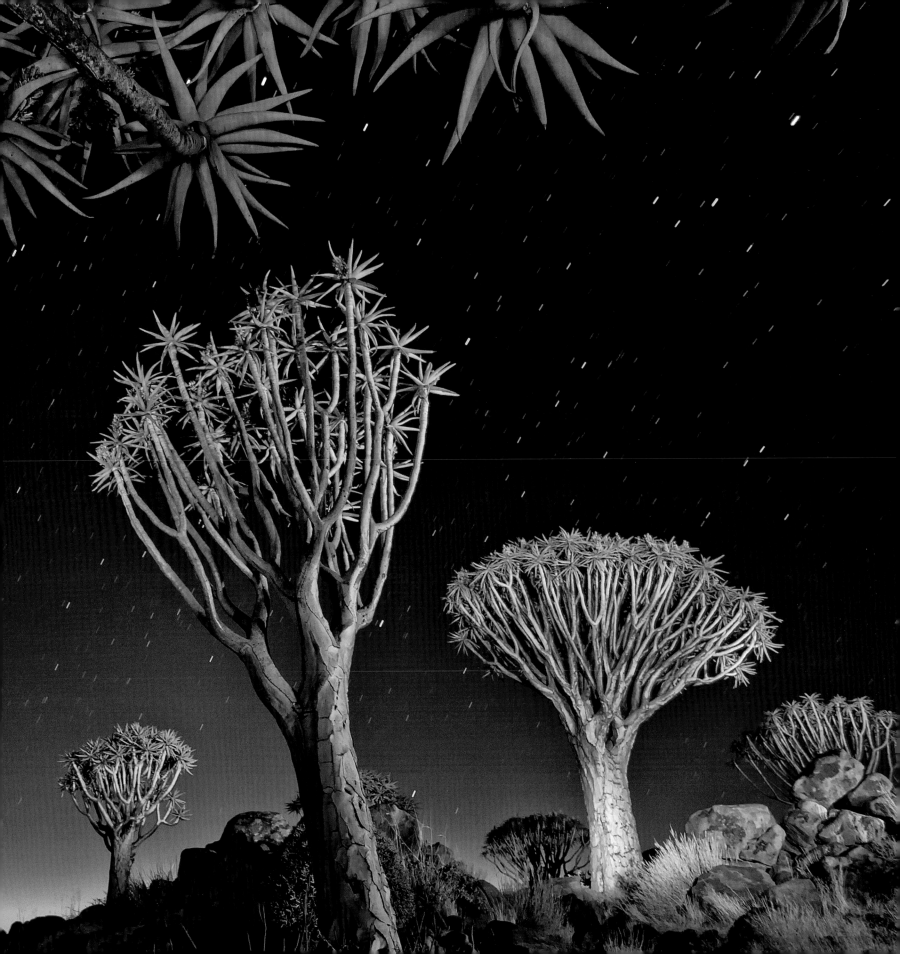

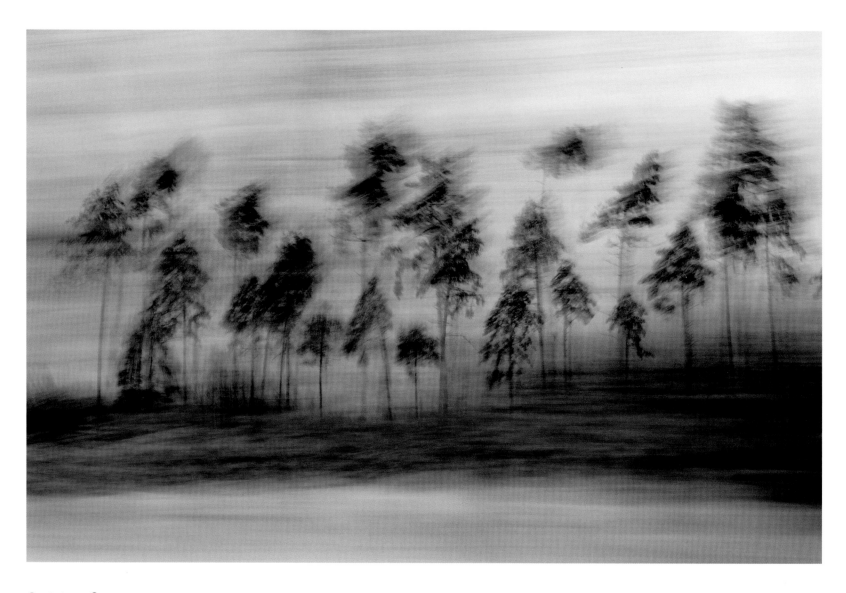

Spirit of winter

COMMENDED

Jonathan Lhoir

BELGIUM

It was a very long drive from Warsaw to the Bieszczady Mountains in the south of Poland, where Jonathan was planning to photograph some of the large mammals the region is famous for. With his friend at the wheel, Jonathan spent the journey photographing the snow-covered forests from the window, taking advantage of the movement. After experimenting for a long time, finding the right shutter speed for the moment, he managed to create the effect he was after when they passed a long line of Scots pines. 'I strive to take images with an artistic feel and design to them,' he says, 'and the use of slow-motion and movement effects often produce my favourite pictures.'

Canon 5D Mark II + 17-40mm f4 lens; 1/4 sec at f20; ISO 160.

Simplicity

COMMENDED

Valter Binotto

ITALY

Valter needed dew for his picture. It was crucial to generate 'bokeh' – a Japanese word for the aesthetic quality of out-of-focus points of light – with a vintage lens. A day of rain followed by a clear night left the dog's tooth violets in a meadow near his home in Possagno, Italy, drenched in dew. 'The light was intense, and there wasn't a breath of air to disturb the scene,' says Valter. He set up before dawn, choosing his flower, and as the first rays of sun touched the petals at the right angle, he took the image – one that captures for him some of the magic of the moment. 'The dog's tooth violet is a simple flower, so common that it is often overlooked,' he says. 'The bokeh effect is a way to honour its great beauty.'

Nikon D300 + Meyer Gorlitz Trioplan 100mm f2.8 lens; 1/1600 sec at f2.8; ISO 160; Gitzo tripod; reflecting panel.

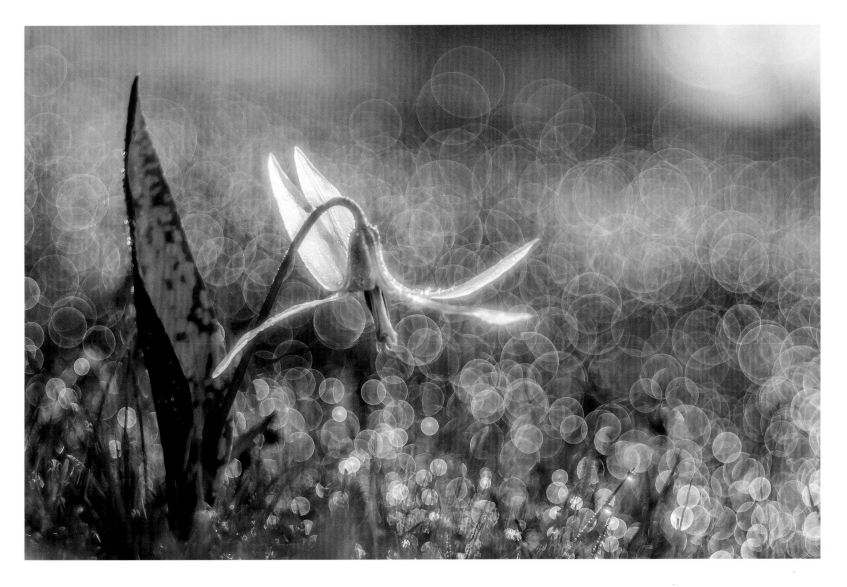

Behaviour: Birds

A picture of bird behaviour that is both artistic and interesting is not easy
to achieve, but a love of birds among photographers always results in
a large number of contenders for the top places.

Sticky situation

WINNER

Isak Pretorius

SOUTH AFRICA

In May, the seafaring lesser noddies head for land
to breed. Their arrival on the tiny island of Cousine
in the Seychelles coincides with peak web size for
the red-legged golden orb-web spiders. The female
spiders, which can grow to the size of a hand,
create colossal conjoined webs up to 1.5 metres
in diameter in which the tiny males gather. These
are woven from extremely strong silk and are
suspended up to six metres above the ground,
high enough to catch passing bats and birds,
though it's flying insects that the spiders are after.
Noddies regularly fly into the webs. Even if they
struggle free, the silk clogs up their feathers so
they can't fly. This noddy was exhausted, says Isak,
'totally still, its fragile wing so fully stretched
that I could see every feather'. The only way to
accentuate the female spider was to crop the
wings. And it was only human intervention that
saved the bird. But a stickier threat awaited it
on the same island: native pisonia, or cabbage
trees. These are favourite nesting places for lesser
noddies, whose feathers get covered in the trees'
sticky seeds. If the load is too heavy, they can't fly,
fall to the ground and die. But there is an ultimate
twist to the story: the corpses provide compost for
the seeds, which give rise to new nesting places
for future generations of noddies.

Canon EOS-1D Mark IV + 70-200mm f2.8 lens; 1/500 sec
at f5.6 (-1 e/v); ISO 1600; Canon 580EX flash.

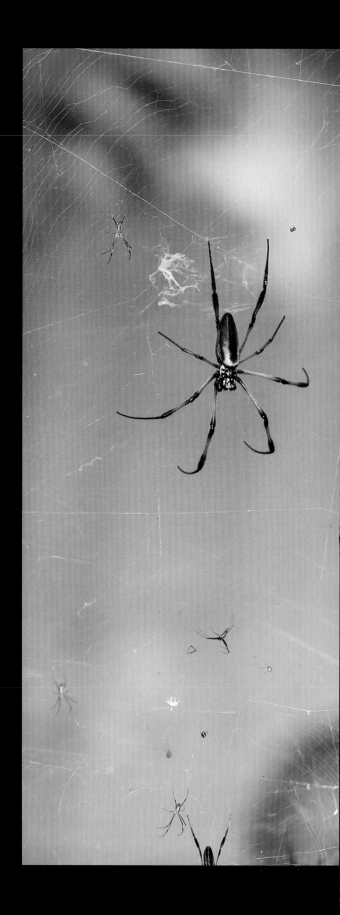

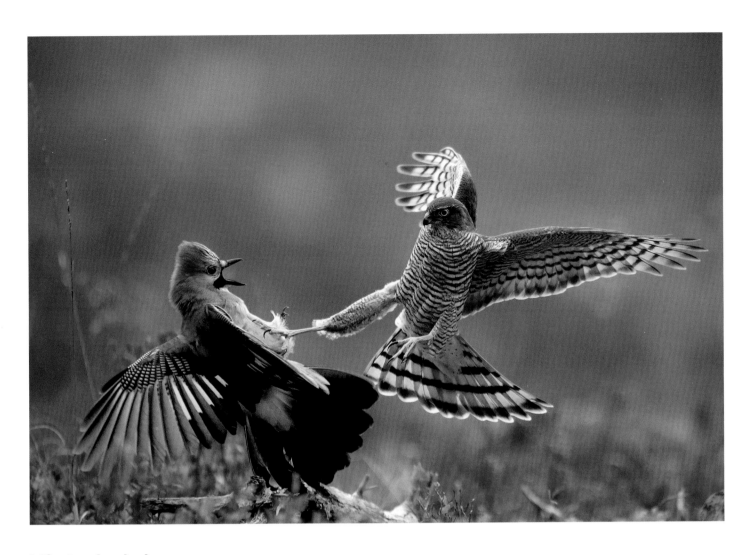

Life in the balance

COMMENDED

Pål Hermansen

NORWAY

Catching a jay isn't easy. When feeding, jays regularly scan the sky for danger, and at the slightest hint of a threat will let out a loud rasping alarm call. So when a pair of sparrowhawks started to frequent a feeding station in front of Pål's hide in Dalen, Norway, he didn't imagine they would catch a jay. What they did do, though, was bring their young for hunting practice. Time after time their attempts failed, but as the youngsters practised striking, Pål was able to practise his shooting skills. 'In the wild, things often happen so fast that by the time you react, the moment is over,' says Pål. 'So I practised pressing the shutter just before an attack began.' On this occasion, he spotted the adult male sparrowhawk lurking nearby and kept focused on the jay until the anticipated strike. Here, the precision and fear expressed in a split second, barely registered by the human eye, manages to capture the height of the action, the moment when life truly hangs in the balance.

Canon EOS 5D Mark III + 300mm lens; 1/3200 sec at f2.8; ISO 2500.

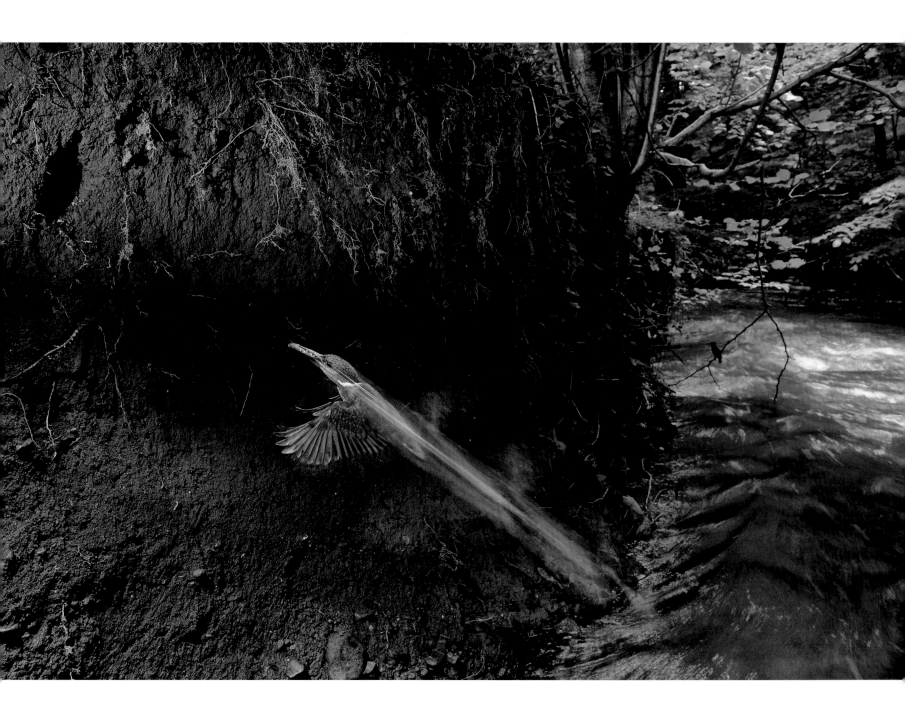

Light path

RUNNER-UP

Charlie Hamilton James

UNITED KINGDOM

This dazzling picture of a kingfisher was taken on a river in southwest England, close to where Charlie lives. He has been passionate about kingfishers since he was a teenager, and as with all his photography, he tries to devise new ways to present familiar scenes and subjects. To create this image took two days and a lot of prior experimentation. Charlie lit the kingfisher's flight path artificially, while simultaneously creating a shadow on the bank to highlight the colourful trajectory. Firing two strobes at the end of the exposure caught the detail of the head and wings. The result is a vivid scene, showing not only the kingfisher taking a fish to its young in their nest hole but also the family's riverine territory. The other parent is on a perch downstream, busy digging a new nest for a second brood.

Canon EOS 5D Mark II + 24mm f1.4 lens + cable release; 1/6 sec at f11; ISO 400; two Canon strobes + one 2.5kw blonde light.

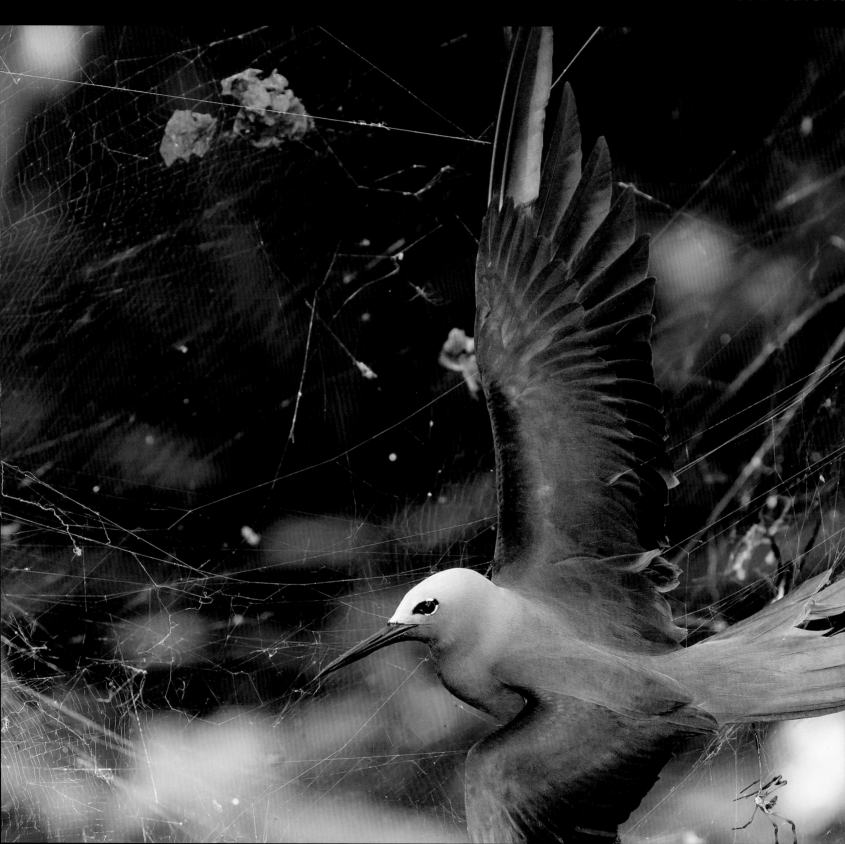

True love

COMMENDED

Steve Race

UNITED KINGDOM

Northern gannets show impressive devotion to each other, pairing for life and returning to the same nest site each year to breed. At the seabird colony on Bempton Cliffs on the Yorkshire coast, Steve has watched gannet behaviour for a number of years. 'Many times I have seen a male offer the female a gift such as a feather or blade of grass,' he says. 'But on this occasion I was amazed to see the male give his partner a necklace of red campion.' Gannets are beautiful birds but their bright white plumage can be challenging to photograph in the contrasting coastal light conditions. Here the challenge was also to create a composition that would reflect the devotion between the pair. The gift was the soft evening light that enhanced the tenderness of the moment.

Canon EOS-1D Mark III + 500mm f4 lens; 1/800 sec at f6.3 (+0.7 e/v); ISO 400.

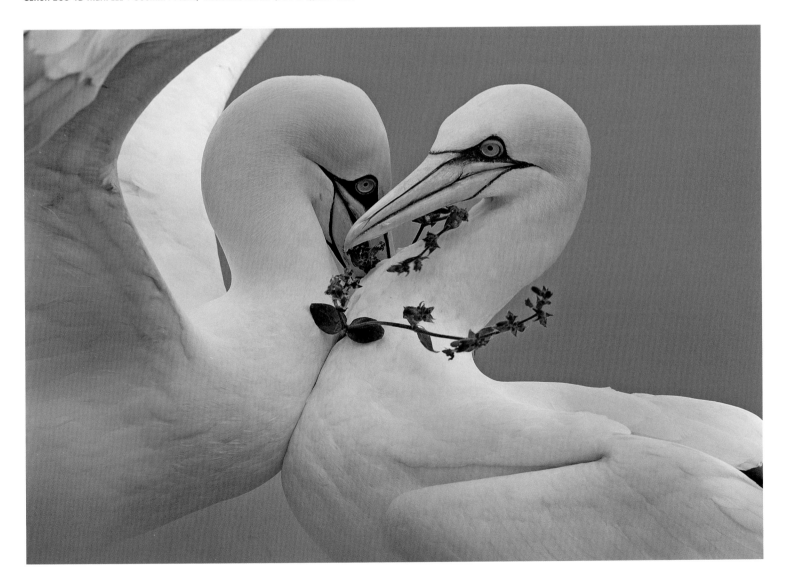

Seed selection

COMMENDED

Ritzel Zoltán

HUNGARY

Near where Ritzel lives, in the Börzsöny region of southern Hungary, the fields are planted up with sunflowers. By winter, the seedheads have been harvested, but a few always remain at the edge of the fields. Where there is a cluster of them in the corners, they attract flocks of tits – ideal for photography. On this occasion, Ritzel decided to use a panoramic lens and set up his camera remotely. 'The image was hard to visualise,' he says, 'and I needed quick reflexes and a lot of concentration and luck to capture the exact moment when a tit plucked out a seed.' He ended up taking photos over several days, experimenting with angles and lighting. But when he finally reviewed the pictures and saw this one, he says, 'I knew immediately that I'd captured the special moment.'

Canon EOS 7D + 18-22mm f3.5 lens; 1/250 sec at f14; ISO 100; in-camera flash; Canon G11 wireless remote; Induro AT 413 tripod.

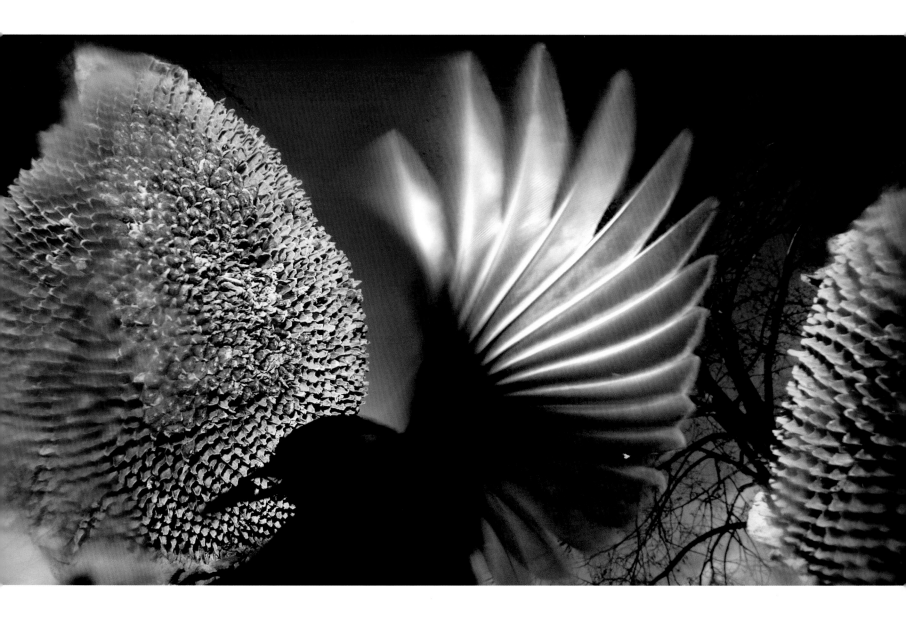

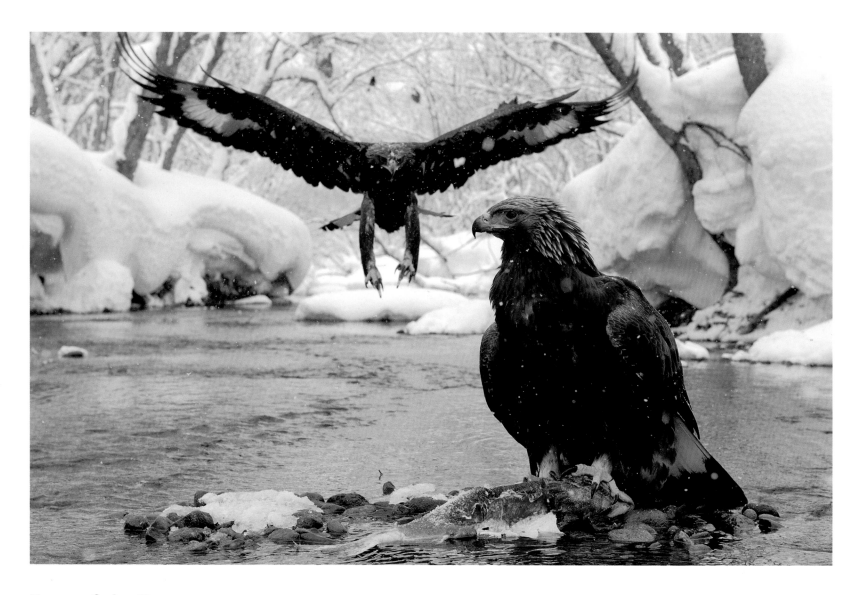

Feast of the East

COMMENDED

Alexey Bezrukov

RUSSIA

One of the wildlife feasts of the Russian Far East is the great salmon run. Millions of Pacific salmon – including Chinook, chum, coho, pink and sockeye – swim upriver to spawn in the watersheds of the South Kamchatka Sanctuary, a great number of them in ending up in Lake Kuril. Dining on the spawning salmon are mammals and birds, including Steller's, white-tailed and golden eagles. Alexey went in spring to photograph the eagles, here at one of the many rivers flowing to the lake. 'The golden eagles seemed to have good table manners,' says Alexey. 'They rarely squabbled and seemed happy to share their catches.' By using a remote shutter release, he was able to get an eye-level view of their dining area.

Nikon D3X + 16-35mm f4 lens; 1/200 sec at f22 (-1 e/v); ISO 100; Nikon SB-900 speedlight; Pixel Oppilas wireless shutter remote; Manfrotto 190 tripod.

Feeding of the five thousand

COMMENDED

Yossi Eshbol

ISRAEL

Each autumn, thousands of great white pelicans on migration from Europe to Africa rest and refuel in Israel. The fishponds at Ma'ayan Zvi in northern Israel are a favourite meal stop. The pelicans usually stay a few days at the most. But on this occasion, much to the fishery keepers' chagrin, 5,000 of them stayed a whole month. A lot of expensive fish were eaten, and the pond guards had their work cut out trying to chase the pelicans away. One day, as Yossi approached the ponds, he saw the pelicans concentrated on the bank. 'I wanted to photograph them with a depth of field and a quick shutter speed to highlight the sheer size of the flock,' says Yossi. 'But the sun was sinking fast, and I could see the guards approaching.' At the moment the birds simultaneously tensed, flashed their bills and looked in the same direction, preparing for take-off, he took this photo. Then they were gone.

Nikon D3 + 600mm f4 lens; 1/200 sec at f18 (-1.3 e/v); ISO 640; Gitzo tripod.

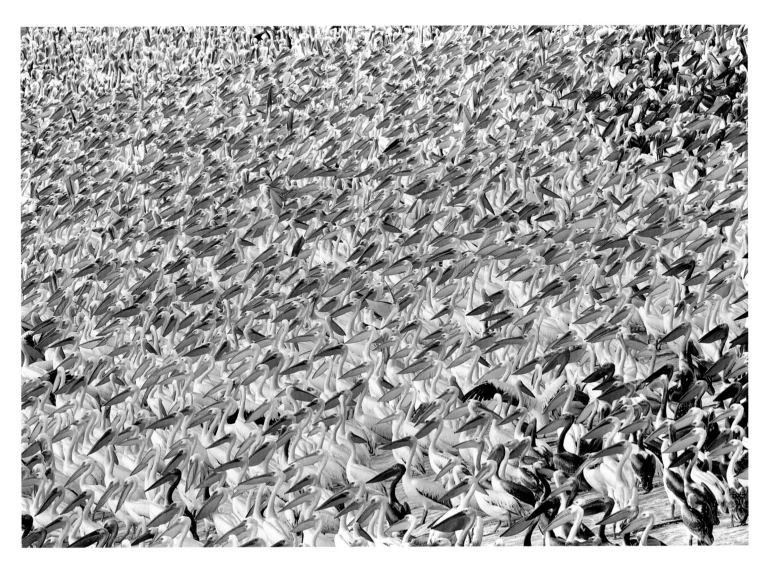

Behaviour: Mammals

Memorable, unusual or dramatic behaviour is needed for this category. Combining that with aesthetic appeal is a challenge that requires patience and fieldcraft as well as skill and a little luck.

The spat

WINNER

Joe McDonald

USA

For several hours, the noisy sounds of courtship and mating were all Joe was treated to as he sat, sweltering in the hot sun, in a boat on the Three Brothers River in Brazil's Pantanal. So when the female jaguar finally emerged from the undergrowth and walked down to the river to drink, Joe was grateful for the photo opportunity. But that was just a start. After slaking her thirst, the female flopped down on the sand. Then the male appeared. After drinking and scent-marking, he approached the female, who was lying in what appeared to be a pose of enticement. At least, that's what both Joe and the male thought. She rose, growled and suddenly charged, slamming the male back as he reared up to avoid her outstretched claws. His own claws were sheathed. 'I couldn't believe the energy and intensity of those three seconds,' says Joe. The pair then disappeared into the undergrowth to resume their courtship, leaving Joe with a sense of awe and a rare, winning image.

Canon EOS-1D Mark IV + 70-300mm f4.5-5.6 lens at 170mm; 1/640 sec at f5; ISO 800.

The golden hour

COMMENDED

Lou Coetzer

SOUTH AFRICA

As the sun came up, a playful mood seemed to infect the whole pride, but these three adolescent males were particularly skittish. Lou was photographing at a remote waterhole in Etosha National Park, Namibia, where the lions had gathered, and he had been there since first light. Now, as the adolescents engaged in an entertaining round of chasing, cuffing, pouncing and wrestling, the scene was bathed in a golden glow. 'It was a rare opportunity', Lou says, 'to see lions in such beautiful light against a simple backdrop. They also had such cute facial expressions, as though they were young cubs again.' But the rough-and-tumble play did present a technical challenge, in terms of the depth of field and the speed needed to capture the action in low light. And then there was the difficulty of keeping them all in the frame without losing a tail. Lou drew on the skills he learned in his earlier careers as a sports photographer and a portrait photographer to capture the action and the spirit of his subjects.

Nikon D4 + 600mm f4 lens + 1.4x teleconverter; 1/4000 sec at f8 (-1.7 e/v); ISO 800.

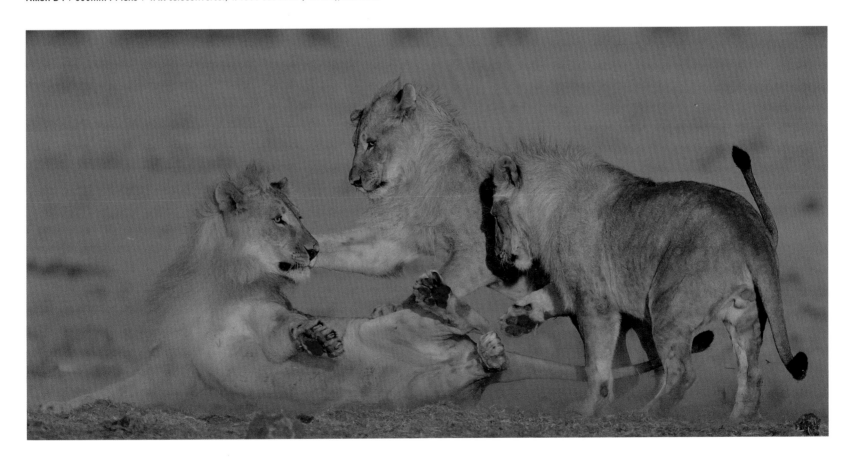

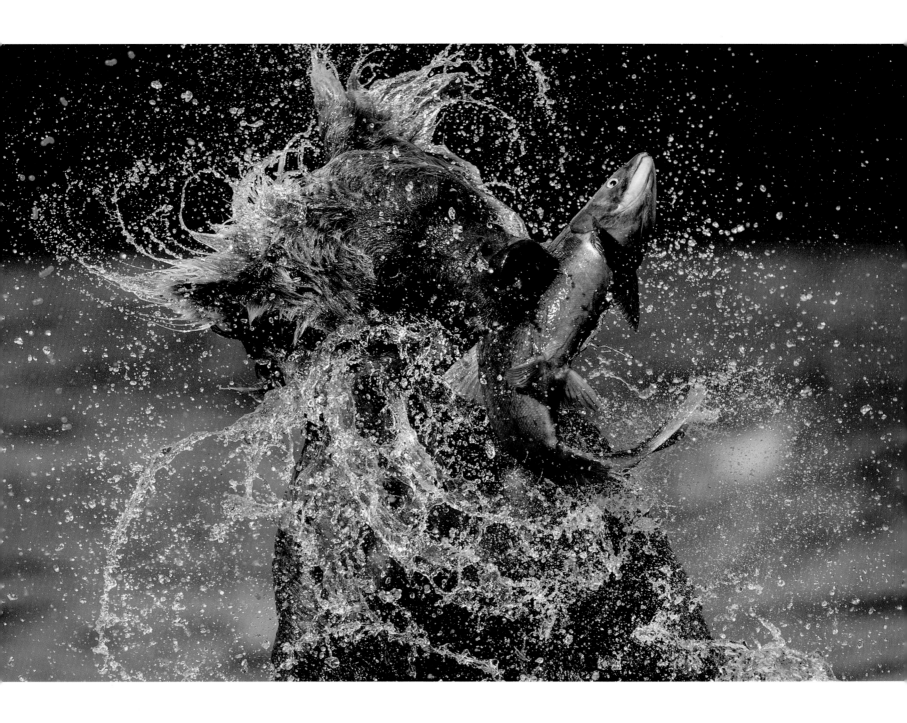

Sockeye catch

SPECIALLY COMMENDED

Valter Bernardeschi

ITALY

Each year between July and September, millions of sockeye salmon migrate from the Pacific back up rivers to the fresh waters of Lake Kuril, to spawn in the waters where they were born. This volcanic crater lake, in the South Kamchatka Sanctuary in the Russian Far East, is the largest sockeye salmon spawning ground in Eurasia. The annual glut attracts Kamchatka brown bears from the surrounding forests to feast on the fish and fatten up for hibernation. Following the example of the bears, Valter waded into the icy water to get the right perspective and to wait for an action moment – a real test of physical endurance. By doing so, 'I almost became one of them,' and 'in the silence of the Garden of Eden I did not think about anything else.' This bear reared up some three metres on its hind legs and scanned the water for fish. Suddenly it pounced on a female salmon swollen with roe, the force sending a string of crimson eggs spinning out of her body.

Nikon D4 + 200-400mm f4 lens at 250mm; 1/8000 sec at f4; ISO 720; Gitzo GT3530s tripod.

Bad boys

RUNNER-UP

Andrew Walmsley

UNITED KINGDOM

The target of these Celebes crested macaques is not the flying cricket but a big male macaque just ahead of them. Andrew was documenting the macaques to raise awareness of these critically endangered primates – found only on Sulawesi and nearby islands – as his contribution to an Indonesian-based conservation project. He was on the beach, concentrating on photographing the male, who was gazing peacefully out to sea, when suddenly the peace was shattered by noise from behind. 'I turned round to see these young males charging. They were screaming, kicking up gravel and making as big a show as possible, their faces full of expression. I had just one chance to capture the energy and passion of the display, as in seconds it was all over. The dominant male stood his ground, took just three paces forward, and the group's bravado crumbled. All four members of the rebellion turned tail and ran.'

Nikon D700 + 300mm f2.8 lens; 1/2000 sec at f2.8; ISO 1000; MB-D10 battery grip.

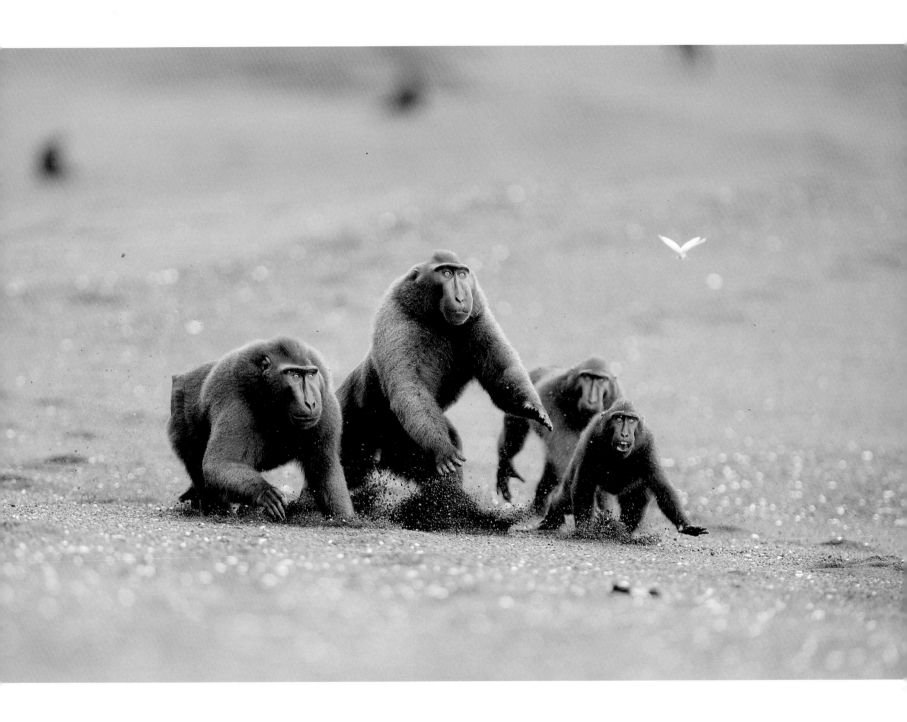

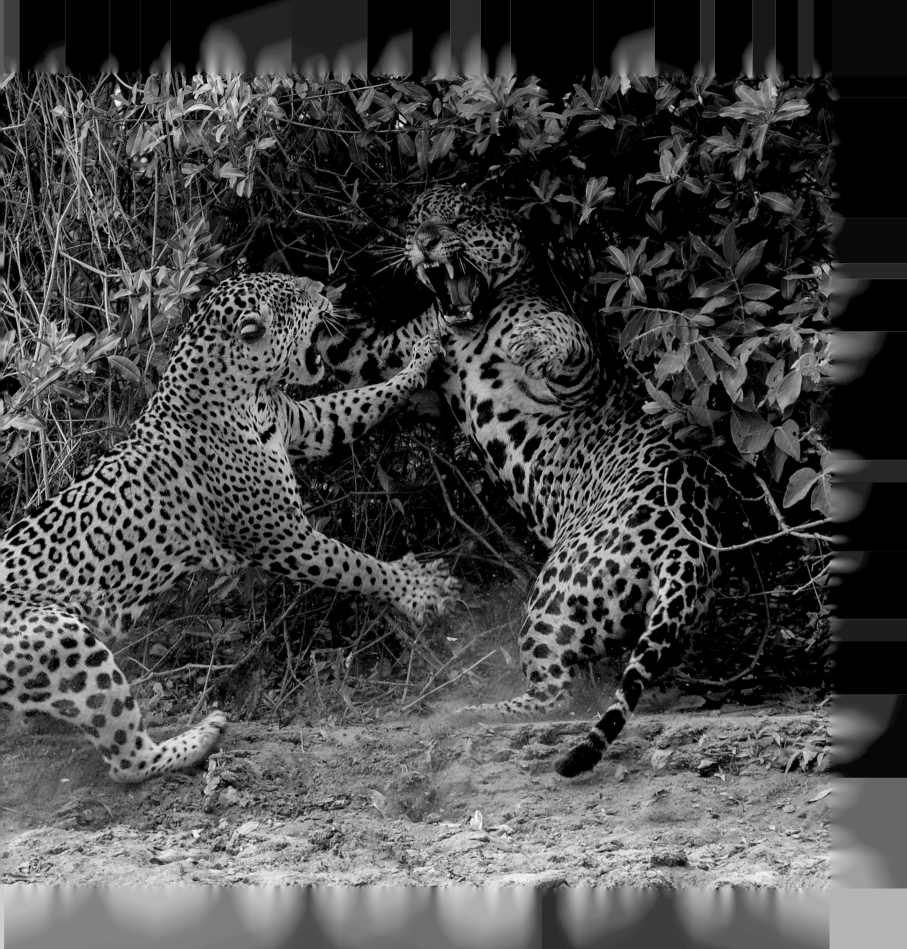

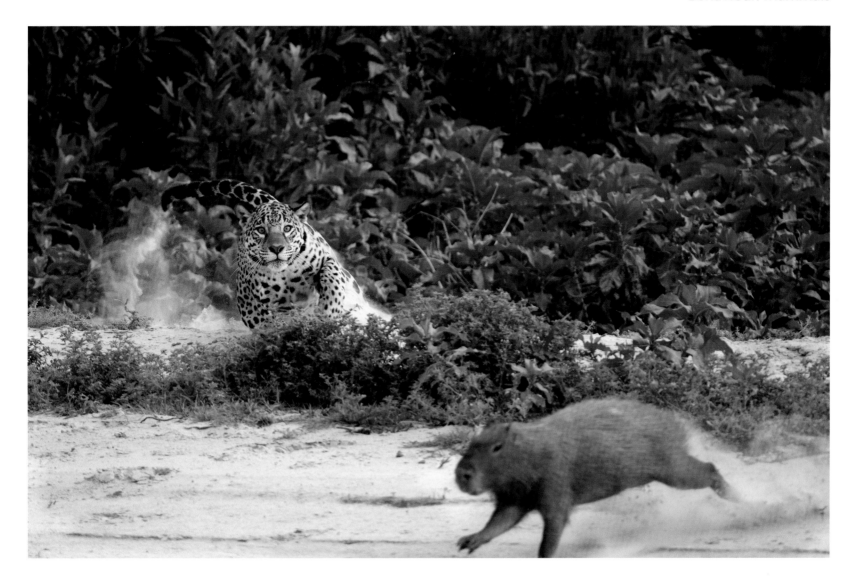

Race for life

COMMENDED

Zig Koch

BRAZIL

Jaguars kill either by throat-bite suffocation or by seizing their prey at the back of the head and then crunching down through the skull with their canines – also used for breaking through turtle shells. One of a jaguar's favourite prey animals is capybara, the world's largest rodent. Since sunrise, Zig had been tracking a female jaguar from a boat on the Rio Cuiabá, in the Mato Grosso state. Ahead of her, he spotted a capybara on the sandy bank. 'I just had time to set up,' he says, before the jaguar burst out of the undergrowth. At the same moment, the capybara saw her and raced for the river. Both animals are competent swimmers, but on this occasion, the capybara had just enough of an advantage to escape with its skull intact.

Nikon D300s + 200-400mm f4 lens; 1/800 sec at f4; ISO 640.

Behaviour:
Cold-blooded Animals

This is the category that encompasses all animals that are not mammals or birds — in other words, the majority, including all the tiny creatures on Earth.

Dive buddy

WINNER

Luis Javier Sandoval

MEXICO

The beaches of the Yucatan Peninsula, Mexico, near Cancún are traditional nesting sites for the endangered green turtle. But as Cancún has also grown as a holiday and dive resort, development has reduced the area available to turtles. Today, though, many nest sites are protected, there are turtle hatcheries to help numbers increase, and there is publicity to help local people and resort owners value the natural riches of the region. Luis earns enough from tourism photography to allow him time to document his beloved wildlife. 'The turtles are so used to seeing people in the water that they think we're just part of the environment,' says Luis, which means he has been able to get to know individuals, recognising them from the markings on their faces. 'This metre-long female, grazing on seagrass, took no notice of me, apart from glancing up briefly.' Recently, Luis has noticed what he suspects may be a new threat: at certain times of the year, a yellowish alga covers some of the seagrass. The suspicion is that the algal growth is the result of sewage from the resort, which has already affected the coral. What is clear is that the turtles avoid eating it.

Nikon D7000 + 10-17mm Tokina fisheye lens at 17mm; 1/125 sec at f10; ISO 100; Sea & Sea YS-120 DUO strobes; Aquatica housing + TLC Arm Set

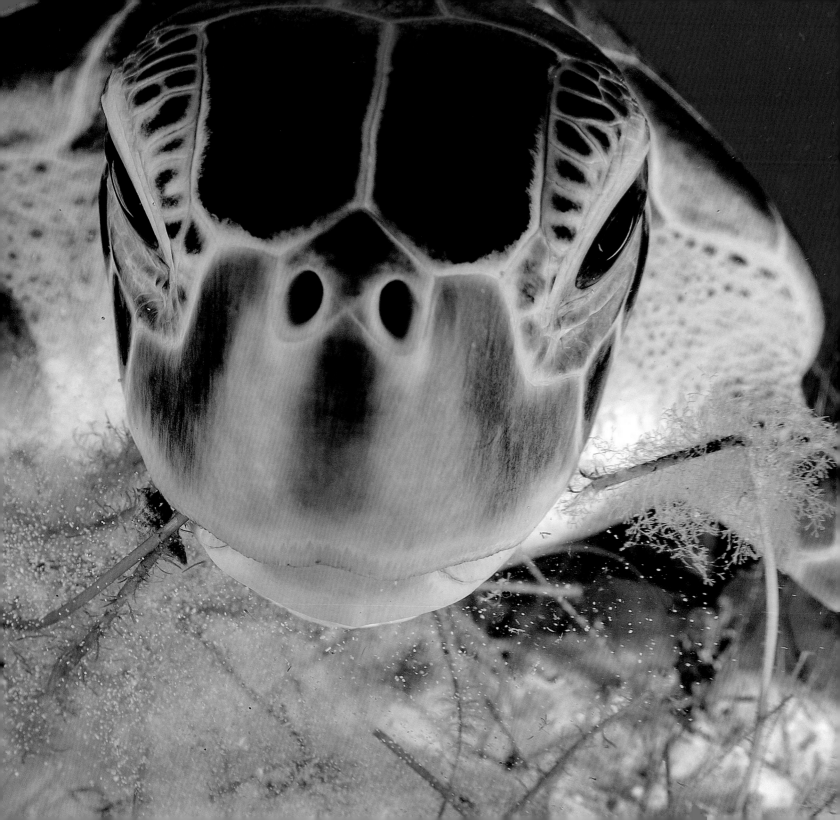

Confusing beauty

RUNNER-UP

Julian Cohen

UNITED KINGDOM/AUSTRALIA

Julian is drawn to the striking patterns formed
when animals group together, whether birds,
mammals or, in this case, fish – a giant school of
them. Here the silversides swirl as one to escape
the potential (human) predator, on the basis that
when each individual is part of a huge, flashing,
moving group, it has less chance of being caught,
both statistically and because of the confusion
effect. Julian was watching them five metres down
underneath a wharf on the island of Samarai in
Milne Bay, Papua New Guinea. 'I would like to say
that I had a creative vision in my mind,' he says.
'I knew that the coral-encrusted pier legs formed
strong and interesting lines, but in truth I was
more concerned with the difficulties in getting
the shot.' To stop his air bubbles from invading the
scene, he had to hold his breath while ascending
slowly, something that if done without caution
can cause a pulmonary embolism. 'I just let the fish
do their own thing and photographed them as they
formed this gloriously abstract pattern above me.'

**Nikon D7000 + Tokina 10-17mm f3.5-4.5 lens; 1/200 sec at
f8; ISO 100; two INON strobes; Seacam Prelude housing.**

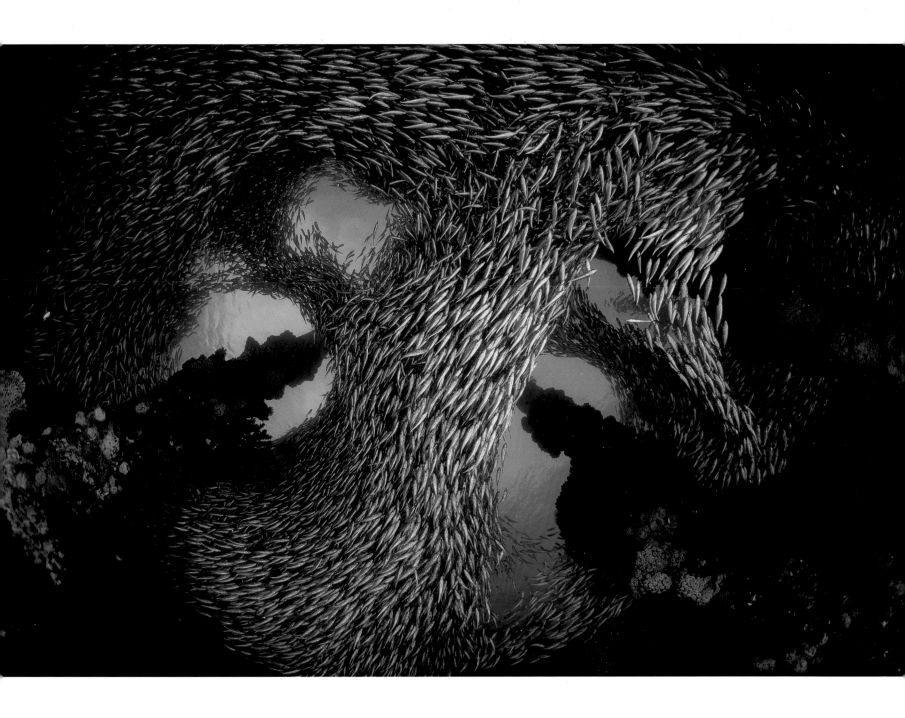

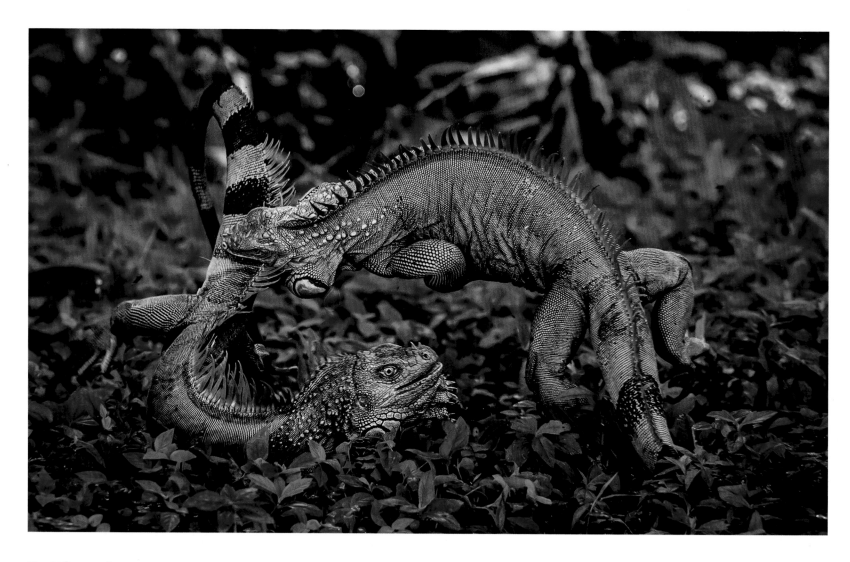

Battle colours

COMMENDED

Gergely Bíró

HUNGARY

A loud commotion in the undergrowth on the bank of the San Carlos River in Costa Rica caught Gergely's attention. He and his friend quickly paddled their canoe closer, and discovered two male green iguanas, in full breeding colours, locked in a violent battle. These dragon-like reptiles – up to two metres long – fight with razor-sharp teeth and whip-like tails during territorial disputes, and the action now was fierce and fast. Focusing on the twisting, leaping iguanas in low light was a challenge. 'I was trying to hold the camera and the big, heavy telephoto lens in the rocking canoe, as we floated downstream,' says Gergely. 'We were lucky not to capsize and lose our gear.' He added that awaiting them in the river were even bigger reptiles: caimans.

Canon EOS 5D Mark III + 300mm f2.8 lens + 1.4x III extender; 1/1250 sec at f7.1; ISO 3200.

Cold-blooded killing

COMMENDED

Alejandro Prieto

MEXICO

Corcovado National Park, on the Pacific coast of Costa Rica, is accessible only by boat or aircraft. Alejandro had travelled there to photograph tapirs, but when he heard bull sharks in the estuary, he set off along the beach to look for them. 'It wasn't long before I heard a lot of splashing,' he says. A few minutes later, out of the sea came a huge crocodile with a large green turtle in its mouth. Alejandro backed into the rainforest to view the action in hiding. 'The crocodile held the turtle by its flipper,' says Alejandro, 'and then, with a flick of its jaws, grabbed the still-living reptile by its head. I willed the crocodile to be still while I struggled to keep the camera steady.' Alejandro managed just one shot before the crocodile headed for the sea and the mouth of the river, clutching its prey.

Nikon D4 + 200-400mm f4 lens; 1/500 sec at f4; ISO 400.

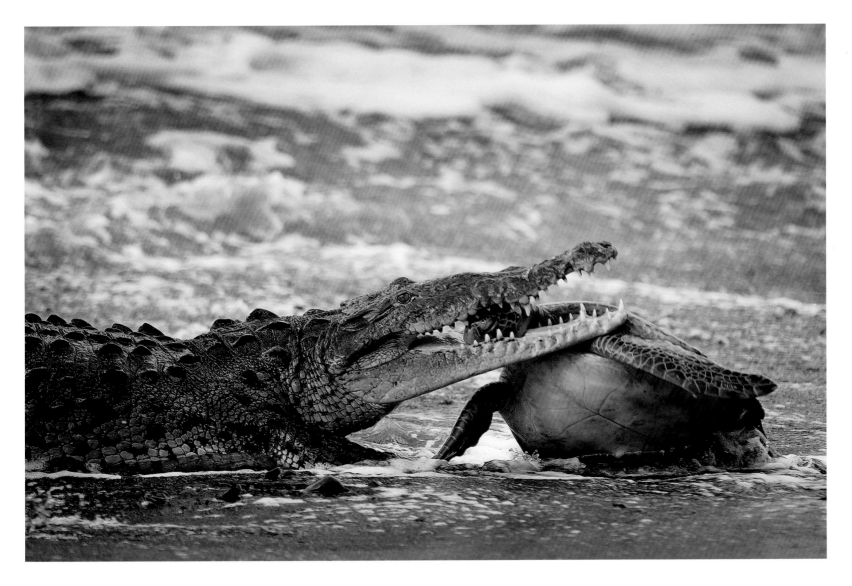

Nature in Black and White

What is required here is skilful use of the black and white medium to create a beautiful or unforgettable composition, whatever the subject.

The greeting

WINNER

Richard Packwood

UNITED KINGDOM

The remains of trees half-submerged in Lake Kariba, the world's largest (by volume) artificial lake, stand sentry around a spit of land. They are ghostly reminders of an ecosystem that was flooded in the late 1950s and early 1960s by the construction of the massive Kariba Dam across the Zambezi River, between Zimbabwe and Zambia. As the lake formed, some 6,000 large animals, including elephants, were relocated as part of Operation Noah, many of them to Matusadona National Park. The lake forms the northern boundary of the park, which is very remote. 'Most people get about by boat,' says Richard. 'We were the first visitors to our camp for five years.' Attracted to this view of the lake by the surreal atmosphere, Richard began watching a lone elephant splashing around in the water. When he realised that another one was fast approaching along the sand spit and that the two would greet each other, he knew he had the chance of a magical shot. That he managed to catch the moment unobscured by any of the trees was a matter of luck, as he had limited time to move position. So for him the shot is a gift from nature.

Nikon D3s + 500mm f4 lens + 1.4x teleconverter; 1/125 sec at f5.6; ISO 400; Gitzo tripod.

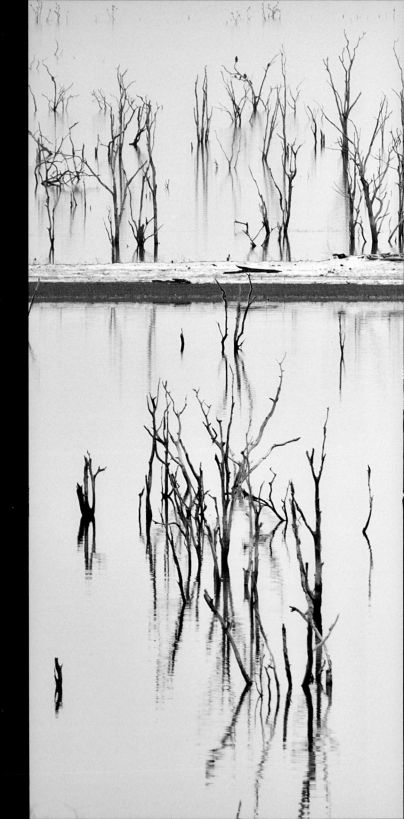

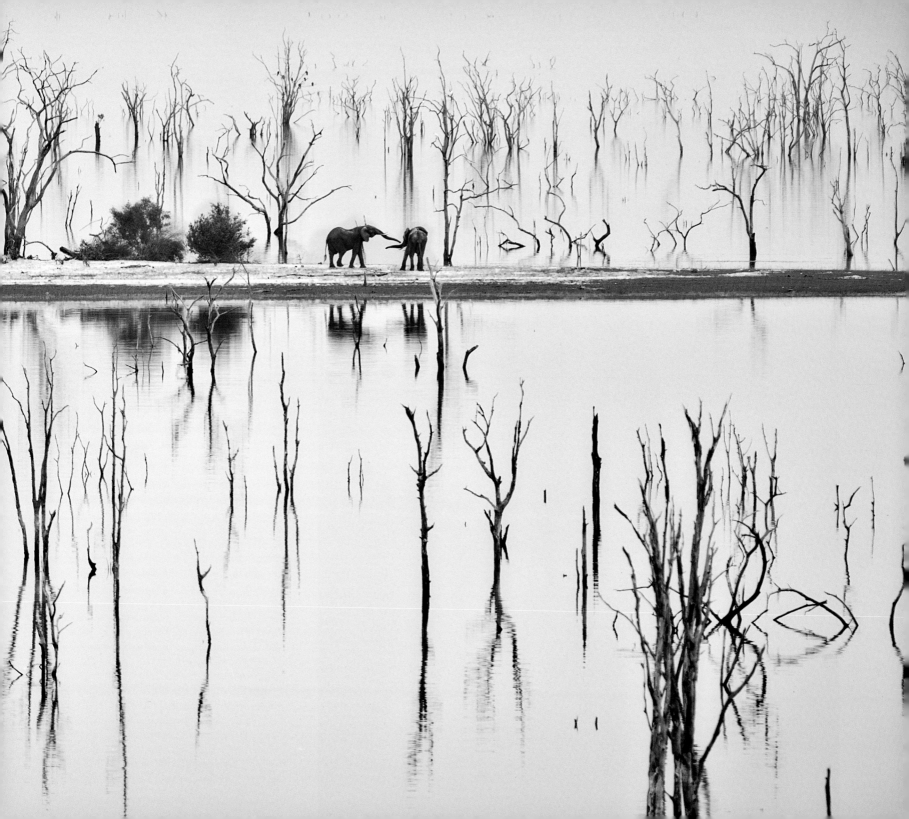

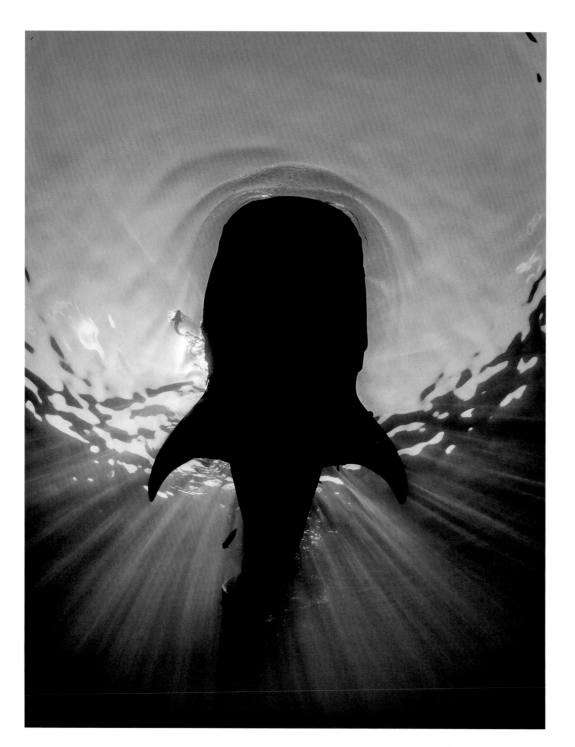

Giant with sunbeams

COMMENDED

Alexander Mustard

UNITED KINGDOM

Alex took this shot in open water in the Caribbean Sea, off Mexico's Yucatan Peninsula, while swimming among a huge aggregation of whale sharks. The sharks were feasting on millions of tuna eggs. One picture he had decided on was a backlit silhouette that would show the bow waves generated by these enormous animals – the world's biggest fish – as they push through the water, scooping up food in their giant mouths. When he spotted the fin of an approaching shark with the sun behind it, he dived down, held his breath and waited for the eight-metre animal to pass overhead so he could shoot it backlit, with the sunbeams spearing into the water along its flanks. 'As serene as the moment looks,' says Alex, 'I was bursting for air. The combination of excitement and awe didn't help, or the fact that I had five metres of water and a shark between me and the surface. But the result was definitely worth it.' The tourism that has developed around the feeding aggregation is also worthwhile. It's put a value on keeping the sharks alive rather than as fodder for the shark-fin industry (a whale shark fin can fetch between $10,000 and $20,000), giving the sharks in Mexican waters a brighter future.

Olympus OM-D E-M5 + Panasonic 8mm fisheye lens; 1/250 sec at f8; ISO 200; Nauticam housing.

Shot in the dark

RUNNER-UP

Andrew Schoeman

SOUTH AFRICA

On a night drive in the Timbavati Nature Reserve, South Africa, Andrew began following two male lions on patrol. From his vehicle, he watched them as they walked at a leisurely pace, scent-marking, investigating smells they came across and, every so often, stopping to listen. The pair eventually settled in a small clearing in the bush, all the while alert to the night sounds. Andrew wanted to capture the intense expression of one of the lions, but it was only when the headlights of an approaching vehicle illuminated part of its face that he got the chance. The second bit of luck was that the lion didn't move in that brief moment, allowing him to be isolated in sharp profile against the blackness of the night.

Nikon D4 + 200-400mm f4 lens; 1/100 sec at f4; ISO 3200; beanbag + panning plate.

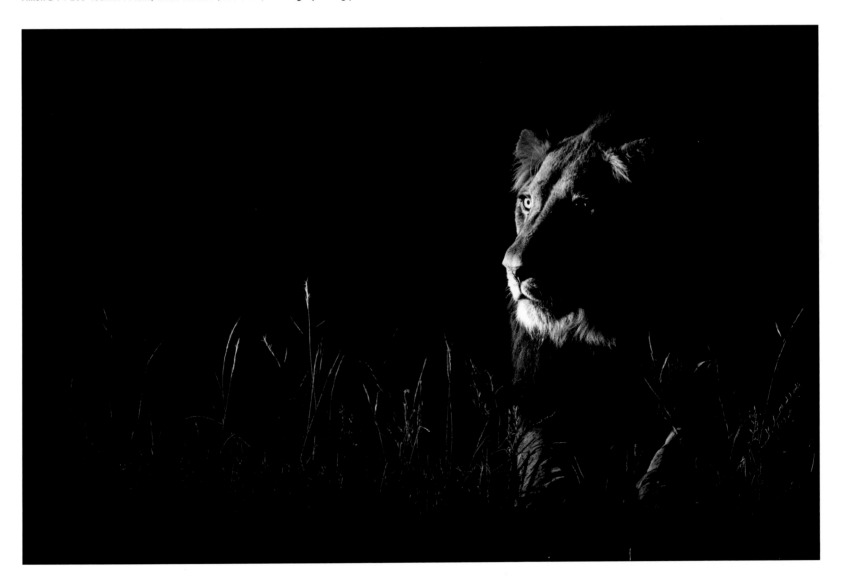

Swan lake

Per-Gunnar Ostby

NORWAY

Each winter, large numbers of whooper swans escape the cold of Siberia and northern Mongolia, their summer breeding grounds, and migrate to Lake Kussharo on Hokkaido, Japan's northern island. Here hot springs around this crater lake keep parts of it ice-free. Photographers head here, too, including Per-Gunnar. 'The restless birds in swirling mists', he says, 'are hugely photogenic, though the conditions can be tricky.' The mist often makes it hard to focus and to choose the correct exposure, and on this trip, sub-zero temperatures meant that Per-Gunnar's main camera body lasted only three days. For the next two weeks, he was in constant fear of his second camera body freezing up. 'The swans in this image,' he adds, 'standing on a stage of snow-sprinkled ice, looked so ethereal that the picture just had to be created in black and white.'

Canon EOS-1D Mark III + 600mm f4 lens; 1/320 sec at f16; ISO 400; Gitzo tripod.

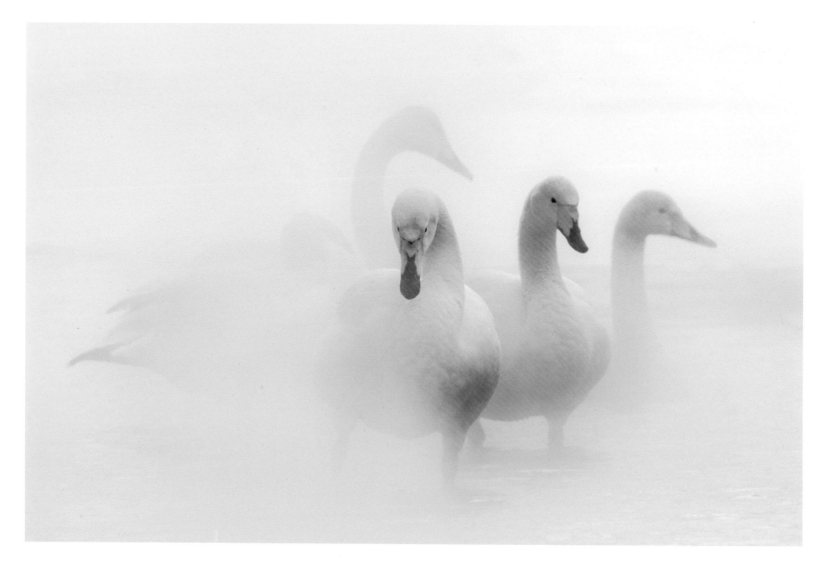

Grand raven

COMMENDED

Chris Aydlett

USA

The raven features a lot in native North American folklore, revered as a deity and regarded as a trickster and even as a mediator between life and death. For visitors to the Grand Canyon in Arizona, this bold, intelligent bird, twice the size of a crow, is a familiar sight, hanging around parking spots, on the lookout for scraps or carrion, or performing acrobatics in the thermals, its loud croaks echoing off the rocks. Chris spotted this one perched on the south rim of the Grand Canyon. Seeing the photographic potential but thinking the bird would fly away as soon as he got out of his car, he grabbed his camera. But it stayed, watching him and giving him time to select a rock as a substitute tripod. Turning the strong midday light to his advantage, Chris created the shot in black and white, to give the scene impact and boost the metallic gloss of the raven's plumage.

Nikon D1X + 15-30mm f3.5 lens; 1/90 sec at f22; ISO 320.

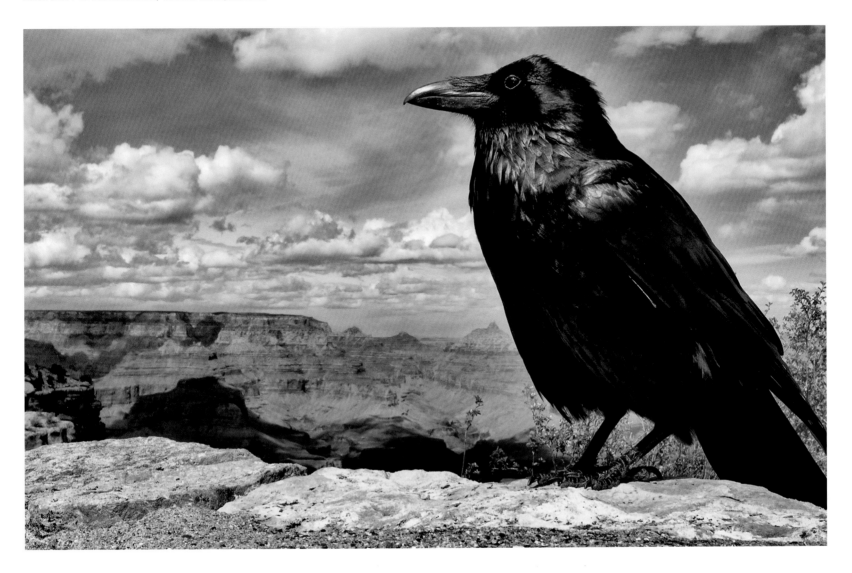

Urban Wildlife

These pictures reveal nature surviving in a human-dominated environment in a surprising or memorable way.

Life after rust

WINNER

Pål Hermansen

NORWAY

Most of the human visitors to the Båstnäs car graveyard in Värmland, Sweden, come to photograph the hundreds of old cars from the 1940s, 50s, 60s and 70s, abandoned to a slow, rusty disintegration and the encroaching vegetation. Some are covered in moss, others enveloped by shrouds of brambles. Seeds take root in ripped upholstery, and plants and trees grow out of windows. But though the cars are worthless now to humans, they have been reborn as habitats for all kinds of animals. 'There are more birds nesting here than anywhere else in the neighbourhood,' says Pål. They have become used to the human visitors, and Pål was able to get just a metre or so away from this song thrush nest. Having rejected Saab and VW, Volvo and Benz, the pair had chosen to raise their brood inside a rusty Opel Rekord. The lighting was particularly difficult, and it took days to work out when the sun was in the right place and how to illuminate the nest with indirect flash. Pål 's intention with this wideangle composition was that the viewer should spend time reading and digesting it. 'My preference is always for shots that tell stories.'

Canon EOS 5D Mark III + 17mm tilt/shift lens (both tilt and shift enabled); 0.3 sec at f11; ISO 250; radio-triggered

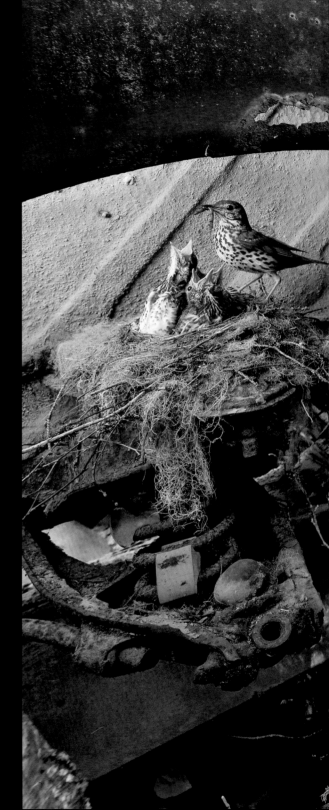

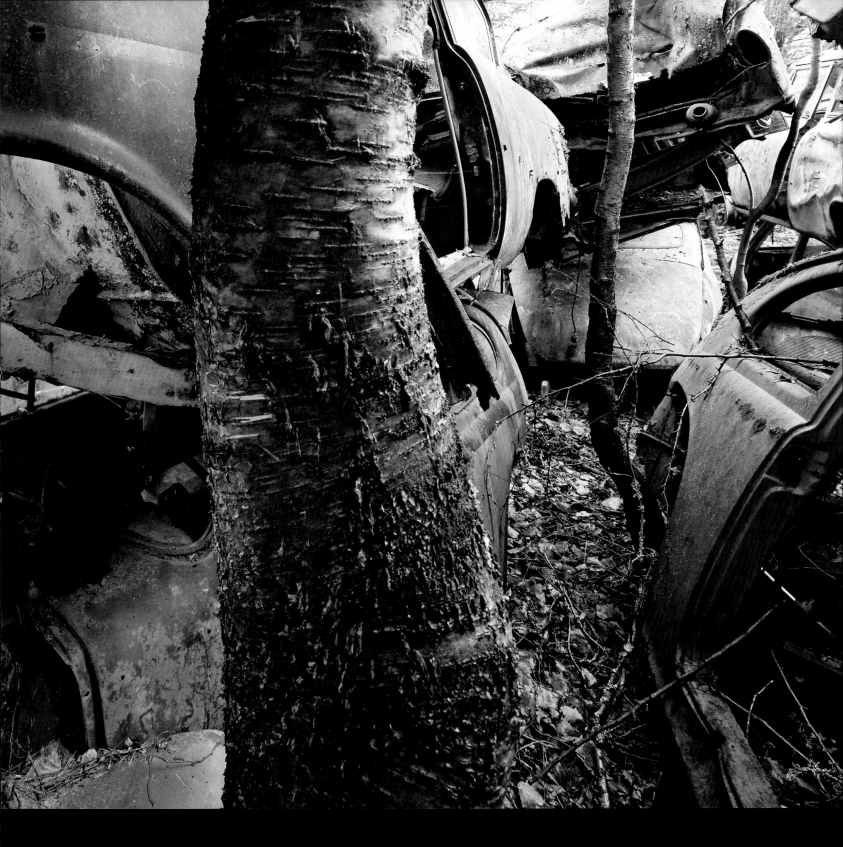

Dam difficult

RUNNER-UP

Stanislao Basileo

ITALY

In June, Stanislao regularly visits the Gran Paradiso National Park in northwest Italy to photograph the alpine ibex, which come down from the peaks in summer to feed on the lower slopes. While driving up to the mountains, he passed Lake Serrù and spotted something extraordinary. An ibex was climbing the face of the dam. Stopping, he quickly walked down to below the dam. The image he took illustrates what appears to be an incredible feat. Though the huge wall appears vertical, a side view would have revealed that the dam was not steep enough to deter an ibex, a wild goat with leg muscles and hooves designed for scaling the steepest of mountain gradients. The attraction for the ibex was the dam wall's salt-encrusted stones – effectively a giant man-made mineral lick.

Nikon D300 + 70-200mm f2.8 lens; 1/1000 sec at f11 (-0.3 e/v); ISO 400.

Primate moments

COMMENDED

Marcos Sobral

PORTUGAL

Varanasi in northern India is one of the oldest continuously inhabited cities. Over hundreds of years, rhesus macaques have adapted to living alongside the people there, even inhabiting temples, where locals feed them as a form of worship. To show the remarkable way that people and monkeys co-exist, Marcos chose a rooftop view so he could look down on a scene. 'I waited for more than an hour at this spot,' Marcos says, 'holding heavy camera gear, being bitten to bits by mosquitoes', while monkeys hung around eyeing his equipment and the light faded.' At last the scene he was hoping for unfolded. The moment he saw the mother, top right, lifting her baby while a pair of monkeys tended their infant close by, he knew he had the shot.

Nikon D700 + 70-200mm lens; 1/100 sec at f8; ISO 640.

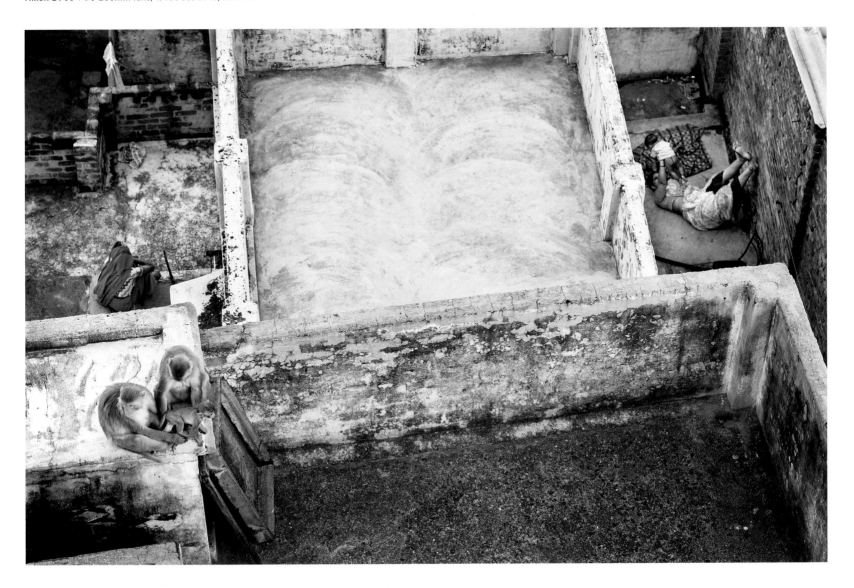

Wildscapes

Here the pictures are of wild, natural landscapes, whether the focus is on land, sky or sea. But they have to convey a sense of scale, drama and wilderness, or the power of the natural forces that have moulded the landscape.

The cauldron

WINNER

Sergey Gorshkov

RUSSIA

On 29 November 2012, Sergey received the call that he had long hoped for. Plosky Tolbachik – one of two volcanoes in the Tolbachik volcanic plateau in central Kamchatka, Russia – had begun to erupt. 'I've gone to the area many times, but it had been 36 years since the last eruption,' he says. 'So I dropped everything and went.' The only way to approach it was by helicopter, but extreme cold (-40°C) meant Sergey had to wait until it was warm enough for the helicopter to take off. Flying towards the volcano, the cloud of ash, smoke and steam was so thick that he couldn't see the crater. But every so often, a strong wind blew the clouds away, and he could see a 200-metre-high fountain of lava spouting out of the crater and fast-flowing, molten rivers of lava running down it (some of these would travel 10 kilometres, sweeping away everything in their path). As gusts of hot air buffeted the helicopter, Sergey worked fast, strapped to the open door. 'I just kept shooting, kept changing lenses and camera angles, knowing I had this one chance, hoping that I'd take one image that might do justice to what I was witnessing.' That was indeed his last chance. At 1am a new explosion happened, the ground rumbled, huge lava bombs threatened the campsite, and a heavy rain of ash and smoke made it impossible to take pictures. Says Sergey, 'I have been to many places and I have seen many extraordinary things, but witnessing the Plosky Tolbachik eruption deeply impressed me.'

Nikon D4 + 16-35mm f4 lens; 1/40 sec at f8; ISO 800.

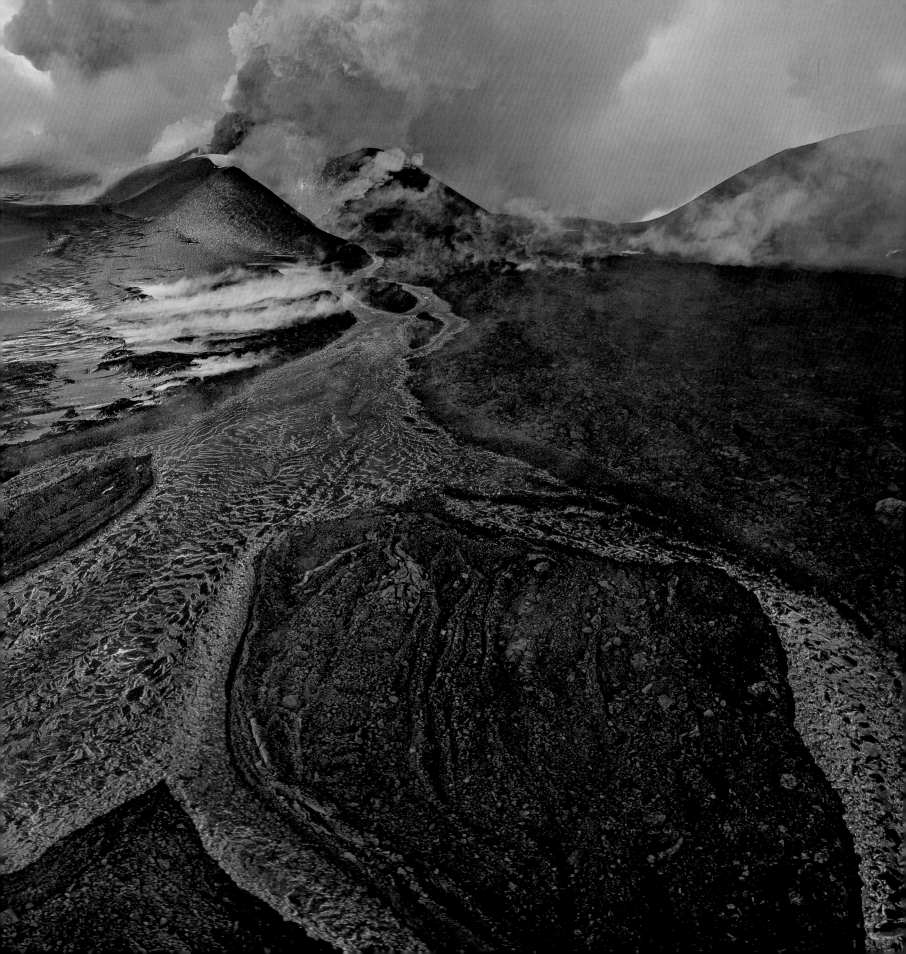

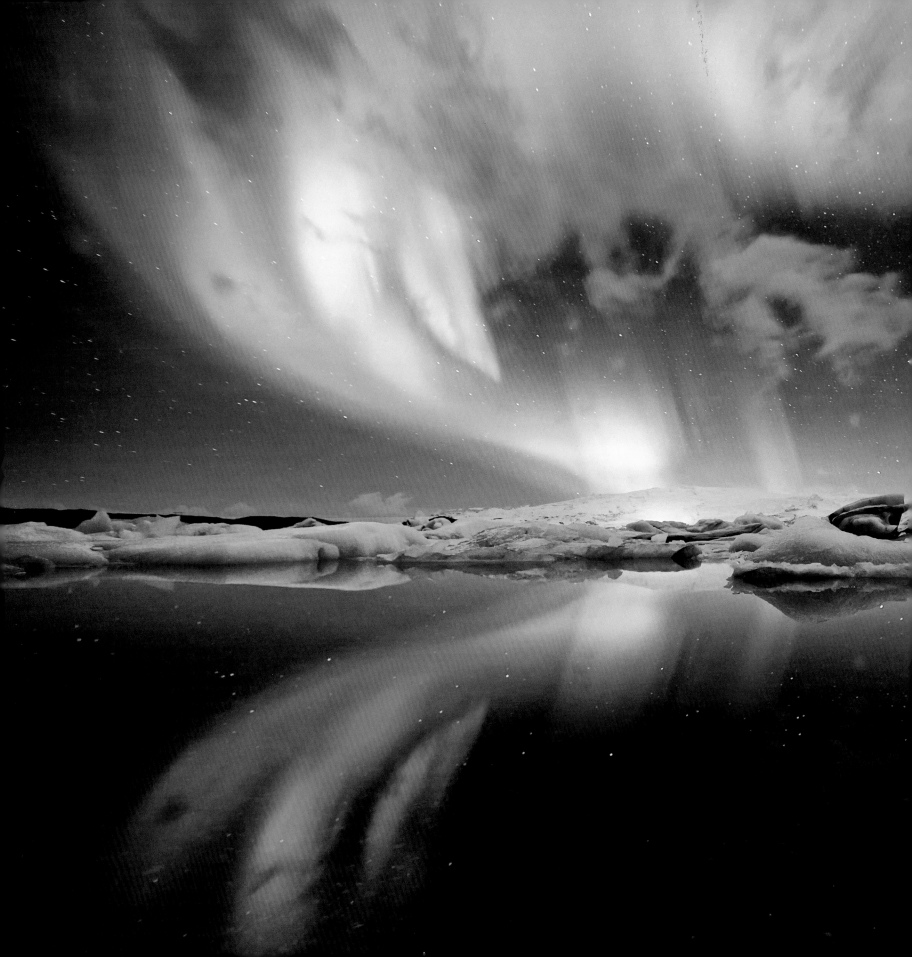

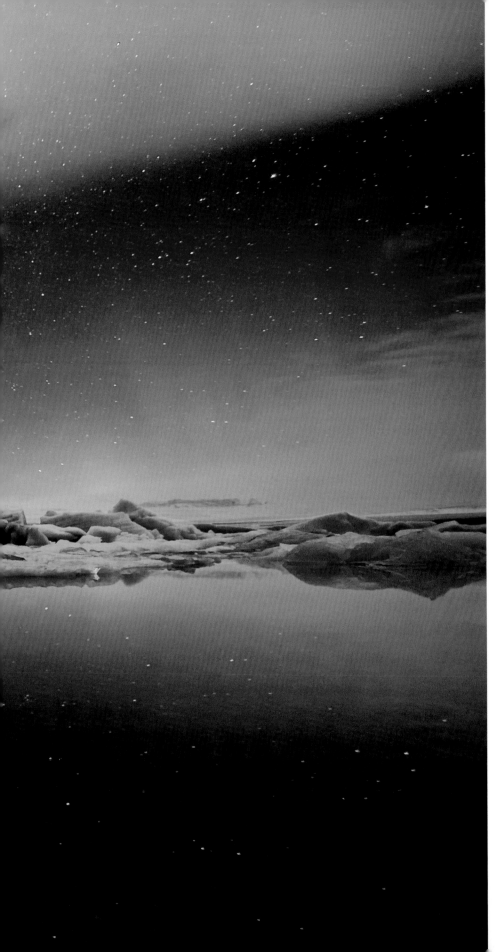

Ice aurora

RUNNER-UP

Ellen Anon

USA

The plan was to drive out to photograph the northern lights over the icebergs in Jökulsárlón, Iceland. But when she arrived, the sky was thick with cloud. 'Not expecting anything extraordinary, I set up close to the car, which was not an ideal location,' says Ellen. So when the clouds suddenly parted, revealing a breathtaking aurora borealis, she grabbed her gear and ran, stumbling in the dark, down to the water's edge. 'I was lucky,' she says. 'The aurora kept swirling, and I had time to set up again.' Lying on her stomach at the edge of the icy water, she used an extreme wide-angle lens to capture the reflection, and placed a lens cloth in front of part of the lens, then slowly raised it, to balance the exposure of the sky against the reflection (the magic-cloth technique). 'It was quite a challenge to force myself to think about the technical details while I was, in fact, feeling overwhelmed by the intensity of the display,' she says. 'This was my favourite image – the swirl of the clouds complementing the unusual colours in the aurora, all mirrored in the lagoon.'

Canon EOS 5D Mark III + 14mm f2.8 II lens; 36.2 sec at f3.5; ISO 1600; Gitzo GT2531 tripod + Really Right Stuff ballhead.

The enchantment

SPECIALLY COMMENDED

Adam Gibbs

UNITED KINGDOM/CANADA

At first, Adam was bothered by the broad strap of shadow on the shoreline opposite. He had hiked to the Enchantments, an area of lakes and tarns in the Alpine Lakes Wilderness in Washington, USA, and had set up camp for a few days. The plan was to photograph the waterfall at the far end of the lake in sunshine. Adam knew he would probably be able to find another, shadow-free viewpoint the next day, but while thinking about moving, the beauty of the overall scene dawned on him. 'The dots of autumn colour of the clumps of Alpine larch and the warm glow of the reflected light on the side of the cliff was sublime,' says Adam. 'So instead of wishing the shadow away, I realised it was a key element of the composition.'

Nikon D800 + 24-120mm f4 lens at 50mm; 1/3 sec at f16; ISO 100.

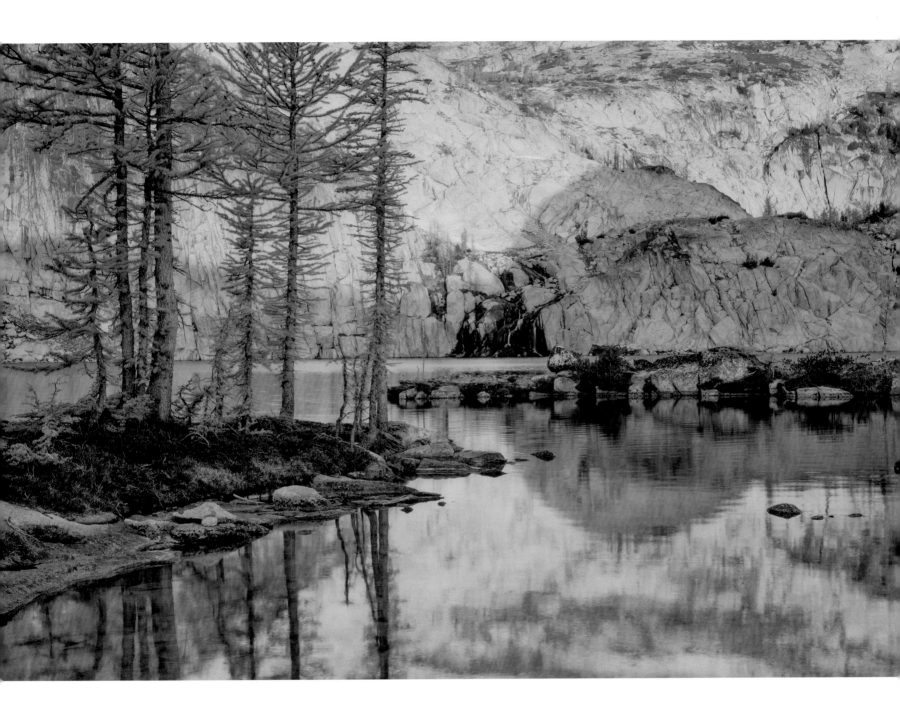

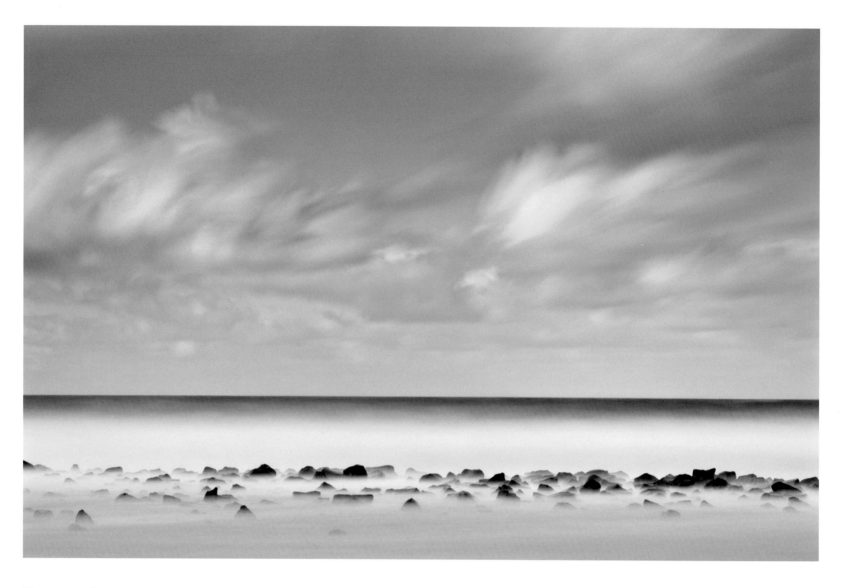

Exposed

COMMENDED

Gerard Leeuw

THE NETHERLANDS

Blue skies, white clouds and sunshine – perfect for a stroll along the beach of Ameland Island in the Netherlands, but holding little promise for a photographer. Then Gerard noticed the rocks – placed there to reduce erosion. There was a strong wind, and as he watched the waves smash against the breakwater, he began to think about the contrast between the wind and water and the solidity of the rocks. A long exposure – he used a tripod with spikes for stability and added pressure to minimise vibration from the wind – eliminated movement in the water but exposed something that he hadn't noticed when taking the shot: the movement of the clouds. 'I like the resulting simplicity,' he says, 'the different layers and the lack of many colours.'

Nikon D800E + 70-200mm f2.8 lens + cable release; 137 sec at f22; ISO 50; Gitzo tripod.

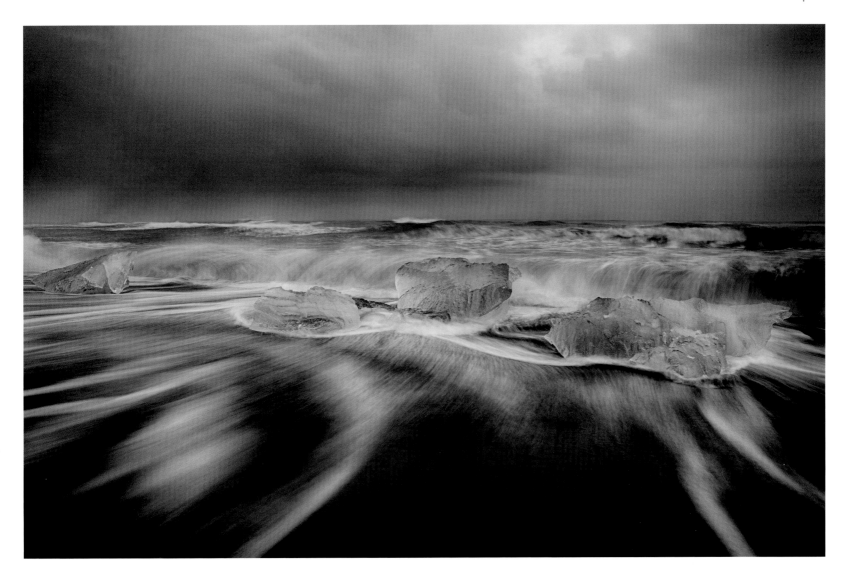

The pull of the sea

COMMENDED

Ellen Anon

USA

The storms in Jökulsárlón, Iceland, lasted all week. During a break in the rain, Ellen set up on the beach. 'The wind was howling, and the rhythmic suck of the undertow was extremely loud,' she says. Ellen wanted to convey the power of the wave at the moment when the next wave was about to rush forward. She used an exposure long enough to show the pull lines in the black sand, with the blue ice midway between the sand and the black clouds, but short enough so the water wasn't rendered too smooth. It took her several attempts – wiping the salty water from the lens between waves – 'to achieve the shot that captures exactly what I was feeling at that moment: a strong sense of awe at the beauty and force of nature.'

Canon EOS 5D Mark III + 24-70mm f2.8 lens + Singh-Ray 5-stop ND filter; 0.7 sec at f22; ISO 125; Gitzo GT2531 tripod + Really Right Stuff ballhead.

Flowerbow

COMMENDED

Olar Barndõk

ESTONIA

When drops of rain in the air refract sunlight in
a particular way and are seen from a particular
vantage point, a rainbow appears in the sky. As the
droplets get smaller, the way the light is dispersed
changes, and the arc's colours weaken. If the
droplets are less than 0.05mm – if there is mist or
fog rather than rain – the arc can become almost
entirely white. Olar saw this magnificent fogbow
on a trip to the Sibillini Mountains National Park
in Italy. It was June, and the valley was a mass of
flowers – poppies, cornflowers and ox-eye daisies.
'After a cold night, a layer of fog lay over the
meadow,' he says. 'Once the sun rose, it started to
lift, and this fogbow appeared. It was so big that
I had to use two stitched images to do it justice.
Its appearance changed minute by minute as the
sun came up, and I knew I had to work quickly.
Ten minutes later, the show was over.'

**Canon EOS 5D Mark II + Canon TS-E 24mm f3.5 II lens;
1/200 sec at f11; ISO 100; Velbon tripod; Jue Ying
wireless shutter remote.**

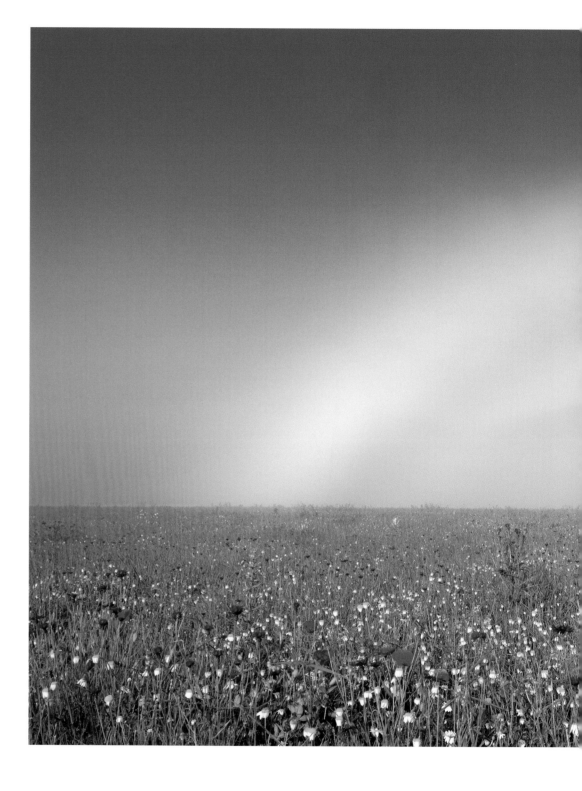

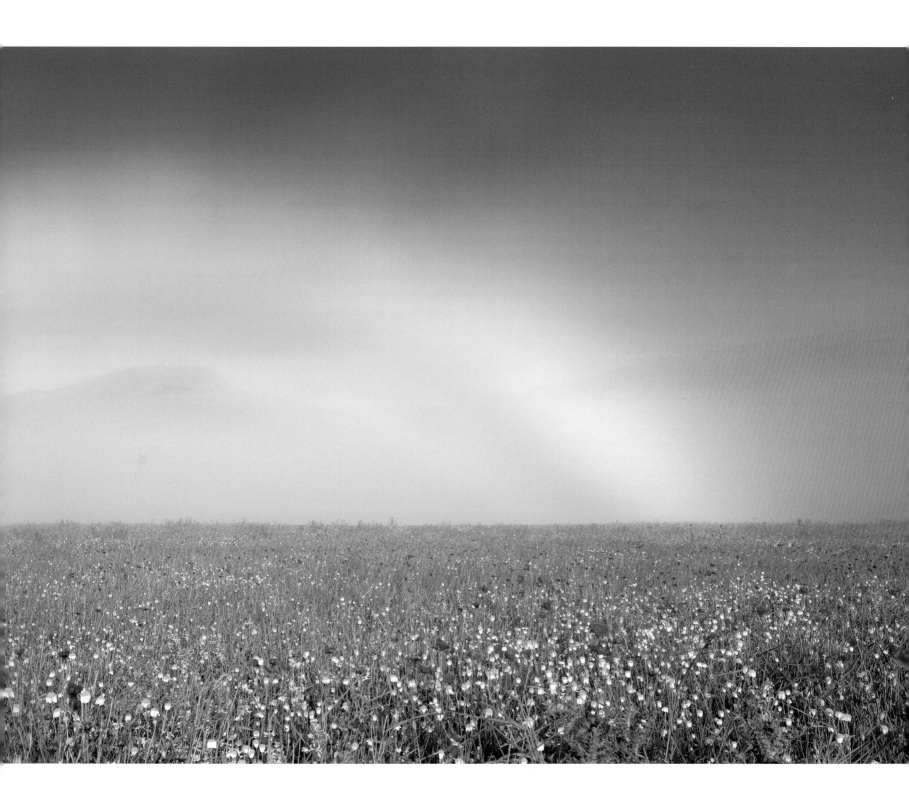

Underwater Worlds

Underwater photography, whether marine or fresh water, requires specific skills, and to win, pictures have to be memorable, either because of what they reveal or because of their aesthetic appeal – and, ideally, both.

Feast of the ancient mariner

WINNER

Brian Skerry

USA

It looks like some kind of inflatable pool toy, but what this turtle is munching on is, in fact, a pyrosome: a free-floating colony of hundreds of thousands of tiny tunicates (filter-feeding zooids) wrapped in a gelatinous 'tunic'. This alone is surprising – leatherbacks tend to dine on jellyfish – but what is more surprising is seeing a leatherback feeding at all. 'Usually, you only see them swimming away,' says Brian. He spotted this individual, nearly two metres long, near the surface in calm water off the island of Pico, in the Azores, Portugal, some distance from where he was snorkelling. As he finned closer, he fully expected the turtle to swim off into the clear blue sea. But it was so engrossed in its meal that he had time to compose a picture. 'The light was tricky,' says Brian. 'I wanted to use ambient light, but because of the position of the sun, it was a delicate dance of slow and gentle movements, trying to position myself to avoid shadows without disturbing the turtle.' Seeing such an elusive creature doing something so rarely witnessed was, he says, 'magical'. Brian continually strives to 'find new ways of creating images and stories that both celebrate the sea and highlight the environmental issues'. He sees this picture as a rare portrait of an incredible survivor – it has a lineage that pre-dates the dinosaurs – now facing a battery of threats, including the warming of the seas as well as fishing, egg-harvesting and coastal development of its nesting areas.

Nikon D3s + 17-35mm lens at 35mm; 1/250 sec at f13; ISO 1600; Subal underwater housing.

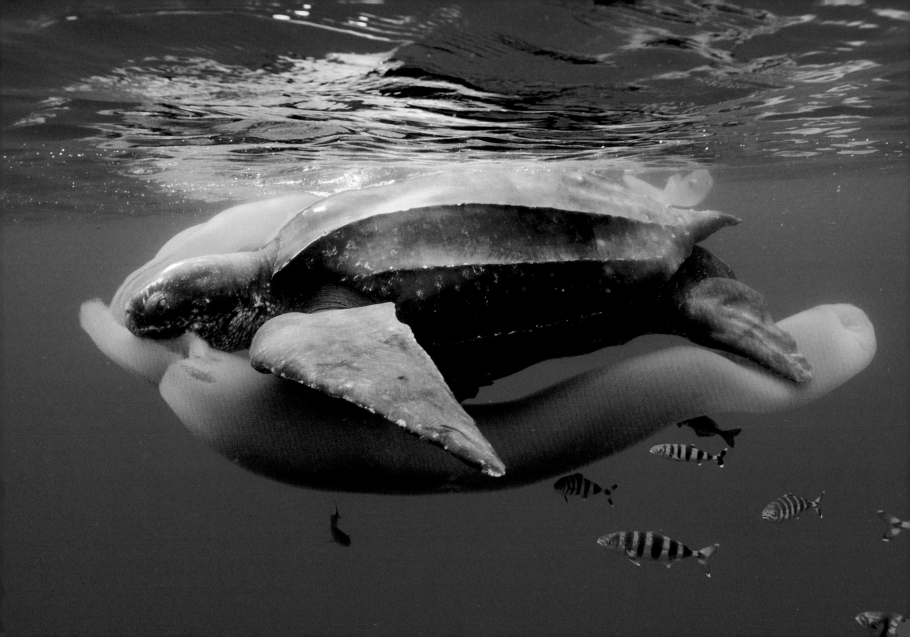

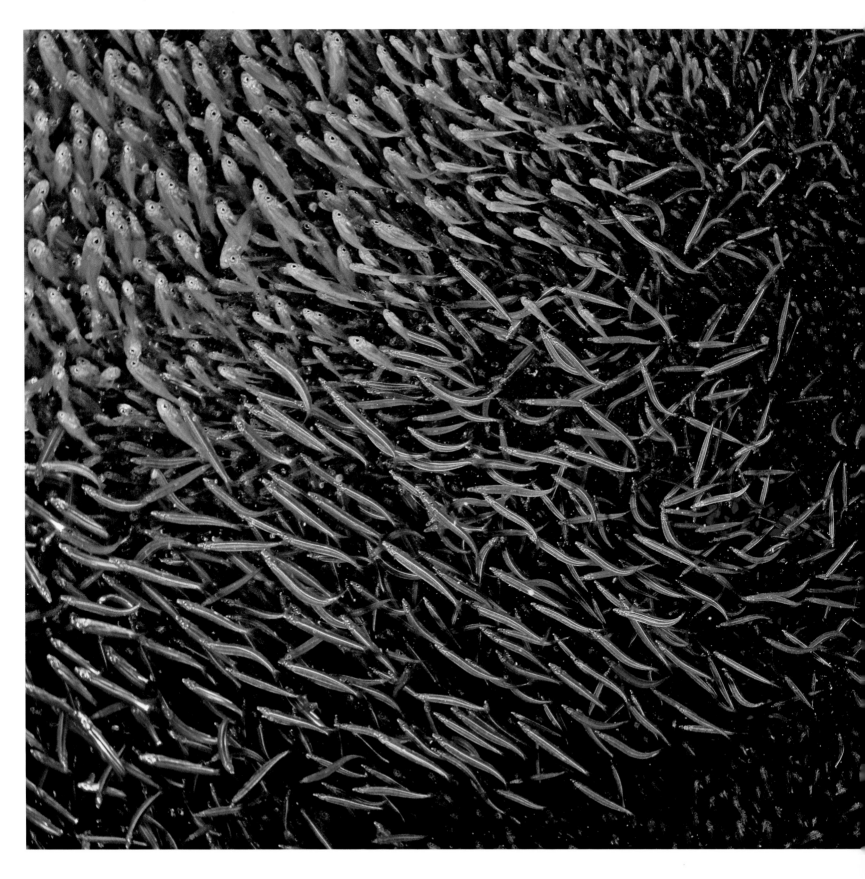

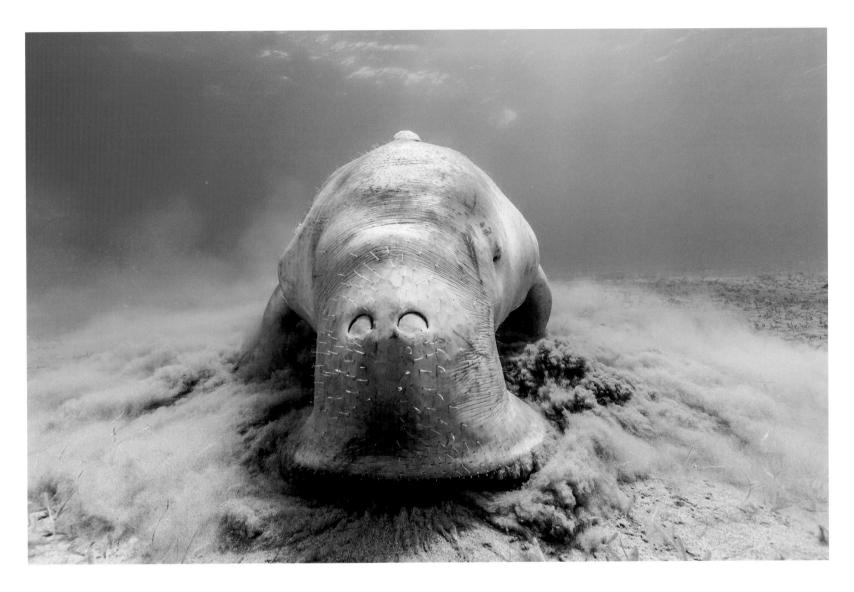

The seagrass sweeper

COMMENDED

Douglas Seifert

USA

Douglas encountered this dugong in a sheltered, shallow bay on the Egyptian coast. It was eating seagrass, its principal food, moving itself along on its flippers rather than its whale-like tail, which it uses for swimming. Every few minutes, after two metres or so of grazing, it would swim to the surface, open its nostrils and take several deep breaths. 'I approached him very slowly to gain his trust,' says Douglas, who took his portrait by lying flat on the sea floor. What struck him was the power of the dugong's muscular snout. It was obvious why the local dive operators had christened this particular individual Dyson: as it cropped the seagrass, it looked as if it was sucking it up with industrial power.

Canon EOS 5D Mark II + 16-35mm f2.8 lens; 1/200 sec at f11; ISO 640; Seacam housing; two INON Z-220 strobes.

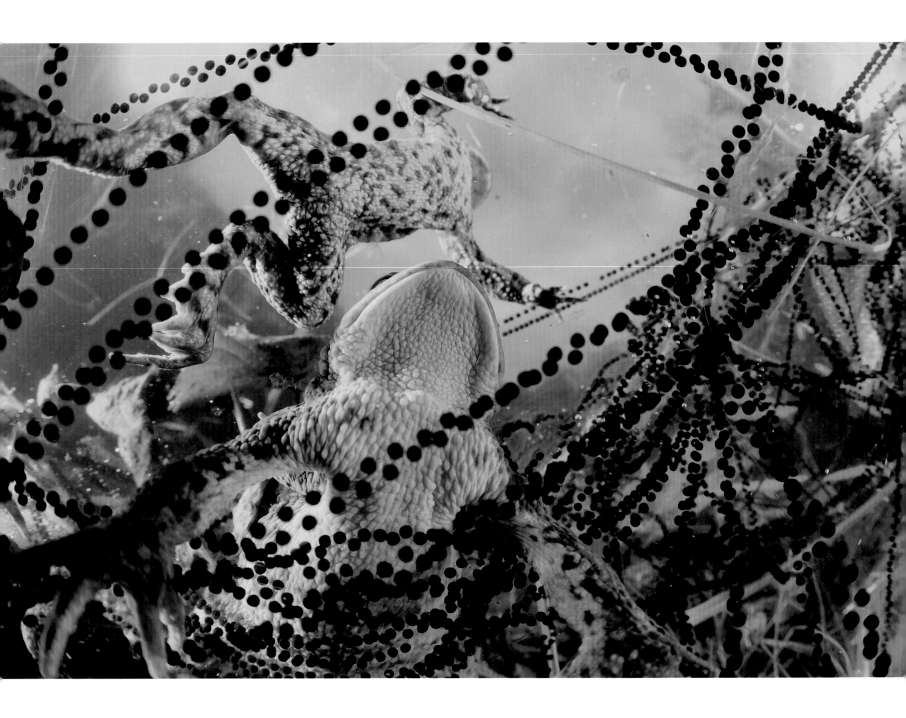

Pearls of spring

SPECIALLY COMMENDED

Solvin Zankl

GERMANY

Each year Solvin marks the end of winter by going into the field to photograph toads emerging from hibernation and migrating to their breeding ponds. This time he went to Solling, in western Germany, a wildlife haven with both forests and wetlands. As the ponds began to boil with mating toads, he chose his location and carefully lowered his camera and strobes into the water, trying to avoid disturbing either the toads or the muddy bottom. By linking his camera to his laptop with a special USB wire, he could see all the activity below the surface and take intimate, non-invasive pictures. 'To me the toadspawn looks like threaded black pearls,' says Solvin, 'neatly arranged in the scenery.' He was captivated by the event, as he has been since childhood, and rejoiced in the spring sunlight and the sounds of frogs, toads and running water – 'all somehow reassuring after the long winter'.

Nikon D3s; modified wide-angle lens; 1/250 sec at f8; Seacam housing; three Seacam strobes; remotely triggered using Nikon Camera Control Pro 2 software.

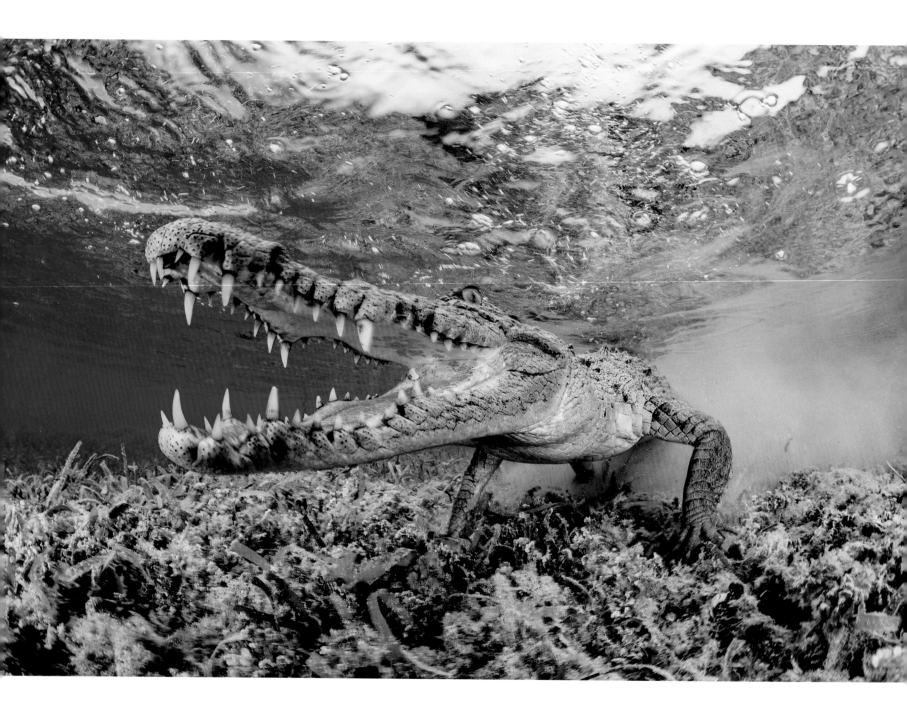

The shy crocodile

SPECIALLY COMMENDED

Jordi Chias Pujol

SPAIN

Jordi was diving at Jardines de la Reina, an archipelago off southern Cuba, when he encountered this juvenile American crocodile. It may have been feeding on fish on a seagrass meadow or on birds in the mangroves overhead. 'I so wanted to photograph it,' says Jordi, 'but it was shy, and trying to tempt it to stay with fish and chicken leftovers made no difference,' because it didn't want to hang around humans. Jordi got lucky on the third day. This time, when he slipped into the water, the crocodile kept watching him, allowing him to take photographs. 'I had to wrestle with my own fear,' says Jordi, 'not of this youngster but of the three-metre-long crocodiles that I had seen in the same area.' He is fascinated by crocodiles, 'with their bizarre beauty' and the fact that they have outlived the dinosaurs. Today, despite their perfect design for survival, many crocodile species are now threatened by habitat loss and poaching.

Canon 5D Mark II + 15mm f2.8 lens; 1/60 sec at f11; ISO 100; custom-built housing; x2 INON strobes.

Lionfish bait

RUNNER-UP

Alex Tattersall

UNITED KINGDOM

The wreck of the SS *Thistlegorm* has lain in the Red Sea at the southern tip of the Sinai Peninsula since 1941. She now attracts many thousands of divers each year, and a host of fishes. In one of the huge holds, Alex discovered more than 20 common lionfish, attracted by a copious supply of prey. He returned over a number of dives, determined to capture as much of the action as possible. Here a lionfish is attacking a huge shoal of silversides and cardinalfish swirling in a huge baitball. 'The synchrony was mesmerising, but the scene was a real challenge to photograph,' says Alex. 'I had to make sure that I didn't overexpose the shiny, silver scales or create "noise" by highlighting particles in the water, while all the time being aware of the site's strong currents.' His determination paid off. He captured an intimate view of the agitated, swirling baitball, with the dazzling predator poised stage right.

Nikon D7000 + Tokina 10-17mm fisheye lens + 1.4x teleconverter; 1/100 sec at f11; ISO 320; two INON z-240 strobes; Nauticam housing; Zen 100mm mini-dome.

The encirclement

COMMENDED

Thomas Haider

AUSTRIA

Large shoals of anchovies are uncommon around Indonesia, and so Thomas knew he was witnessing something special when he saw an enormous shoal encircling a rock off Indonesia's West Papua province. As he approached, it separated like a curtain and encircled him in a fountain formation. This revealed a group of longfin batfish close to the rock, and below them fusiliers and jacks. Fish shoal to form one alert whole, and predators and potentially dangerous animals would normally be on the outside, but here the larger fish – and Thomas – were surrounded. 'It was a tricky scene to encompass in one image,' says Thomas, but he did manage to catch both the moment and the behaviour.

Nikon D300 + Tokina 10-17mm f3.5-4.5 lens at 10mm; 1/60 sec at f8; Subal housing + domeport; 2x Subtronic Nova strobes.

The great gape

COMMENDED

Bence Máté

HUNGARY

For several years Bence has been photographing the huge Dalmatian pelicans of Lake Kerkini in Greece, fascinated by their size, shape and spectacular breeding colours – bright orange bill pouches set against silvery-white plumage. In this breeding site, where they are used to being fed fish offal by the local fishermen, they are unafraid of people. What Bence most wanted was an underwater view of the great bills at work. Thwarted by the poor visibility of the water, his vision became an obsession. So he built a large, floating, deep-water pool, designed a complicated water-filtering system and then set about devising a way to photograph the birds remotely. To control what was being taken under water and to check the images on a laptop, he devised a special remote-control system involving a lot of wire. Eventually, attracted by dead-fish bait, the pelicans started to hunt in the clear pool. After six weeks of hard work, he achieved his vision with this single but unforgettable image of wide-gaping pelicans from a fish's point of view.

Nikon D300s + Tokina 10-17mm f3.5-4.5 lens; 1/320 sec at f20; ISO 400; Subal housing; two SB-800 flashes; two Ikelite flashes; floating remote-control system.

Creative Visions

This category is for conceptual pictures – original and surprising views of nature, whether figurative or abstract.

Snow moment

WINNER

Jasper Doest

THE NETHERLANDS

When photographing the famous Japanese macaques around the hotsprings of Jigokudani, central Japan, Jasper had become fascinated by the surreal effects created by the arrival of a cold wind. Occasionally, a blast would blow through the steam rising off the pools. If it was snowing, the result would be a mesmerising pattern of swirling steam and snowflakes, which would whirl around any macaques warming up in the pools. But capturing the moment required total luck – for Jasper to be there when the wind blew and for the monkeys to be in the pool. For that luck to arrive, he had to wait another year. Returning the next winter, he determined to get the shot he'd been obsessing about. He set up using a polariser to remove reflections from the water and create a dark contrasting background, and got ready to use fill-flash to catch the snowflakes. 'As it kept snowing, I stood there, willing the wind to pick up. I felt it just had to happen – sometimes you can push your luck if I you just wait long enough.' But as the steam started swirling above the water, there wasn't a monkey in sight. 'All of a sudden one adult appeared and jumped on a rock in the middle of the pool. When he started shaking off the snow, I knew this was the moment.'

Nikon D4 + 24-70mm f2.8 lens at 55mm + polarising filter; 1/100 sec at f11; ISO 1600; Nikon SB-800 flash.

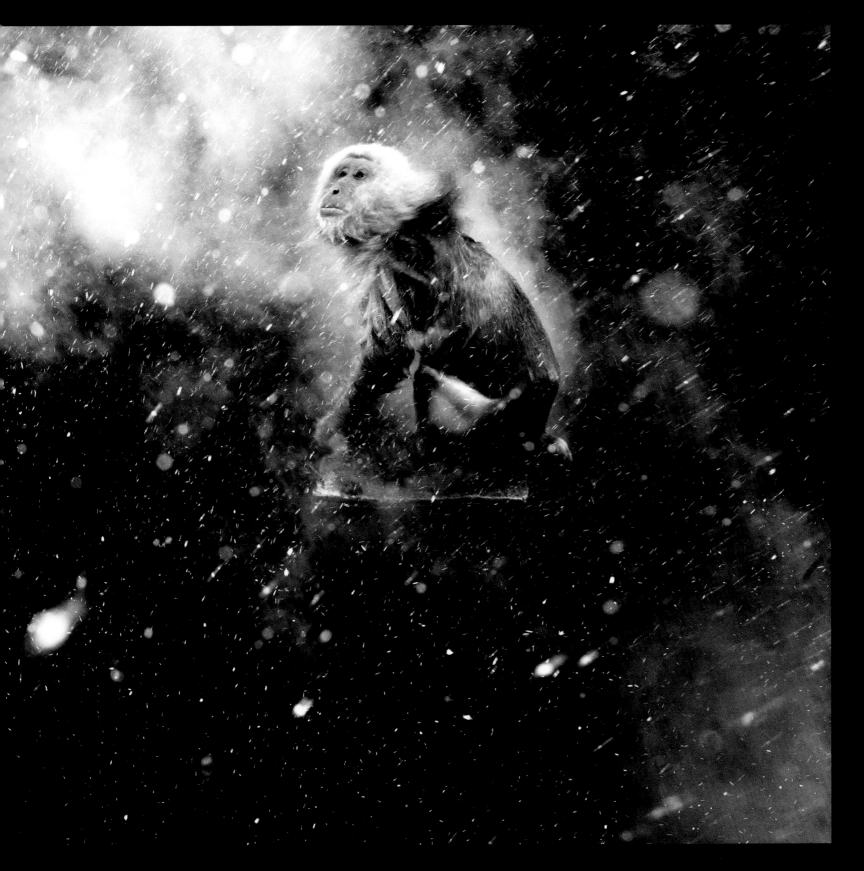

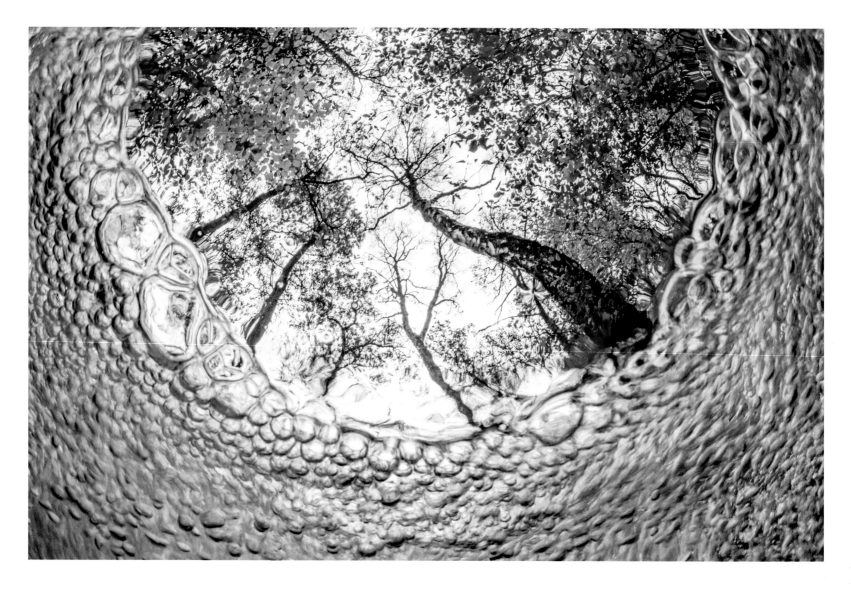

Fish-eye view

RUNNER-UP

Theo Bosboom

THE NETHERLANDS

Miniature, underwater landscapes fascinate Theo, particularly ones in fast-flowing streams and brooks. On the day he took this picture, he was experimenting with the effects under a small waterfall in a brook near his home in the Netherlands. Kneeling in waders and holding his camera under water, he shot looking up through the effervescent surface below the fall, using the bubbles to frame the scene of autumn trees. 'I love taking pictures that show a fresh perspective on nature,' says Theo. His biggest challenges were not being able to look through the viewfinder to see what he was doing and avoiding having his head appear in the wide angle of the frame.

Canon EOS 5D3 + 8-15mm f4 lens; 1/100 sec at f22; ISO 1600; Nauticam housing.

Magic mushrooms

COMMENDED

Agorastos Papatsanis

GREECE

The taller of these two parasol mushrooms is just 30 centimetres. That is tall for a parasol, but their prominence against the tree trunks behind is a slight optical illusion, the result of an in-camera double exposure. Agorastos found the fungi growing in woodland in the Grevena region of Greece, and was fascinated by the subtle browns of the scales of their 'skins' and their relationship to each other. Photographing them from ground level, he chose to expose separately for the young spruce trees, using their trunks as a frame for the emerging fruiting bodies, and to set them against the backdrop of light coming through the autumn leaves at the woodland edge. What he wanted to capture was the fairytale feel of the scene. 'Nature is the true designer,' he says.

Nikon D700 + 70-200mm f2.8 lens; 1/60 sec at f2.8 (-0.3 e/v); ISO 100.

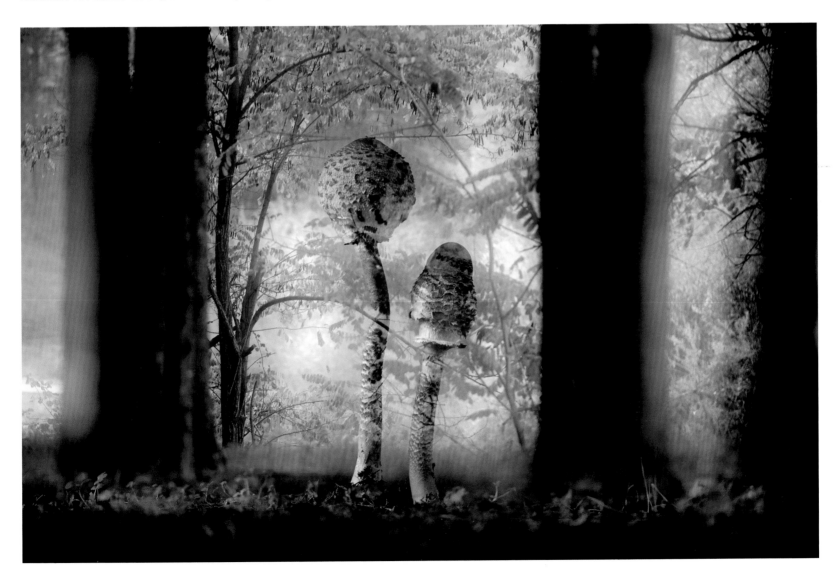

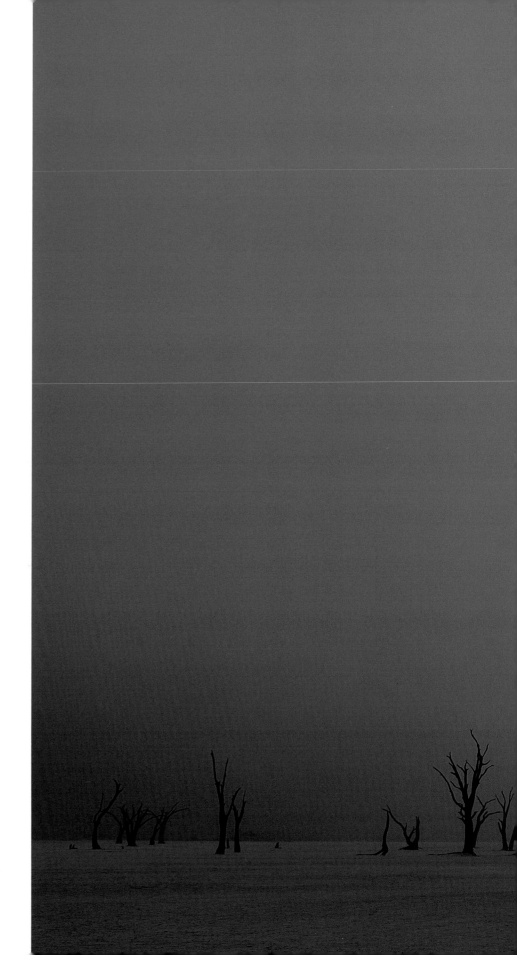

Resurrection

COMMENDED

Marsel van Oosten

THE NETHERLANDS

Deadvlei is a popular location for photography, but Marsel had an image in his mind that would be very different from all those taken before. The key ingredient was fog. Deadvlei, though, is in the Namibian Desert, where fog occurs only a handful of times a year, when an easterly wind blows in from the Atlantic. So it was many years before Marsel got his shot. Surrounded by some of the highest sand dunes in the world, Deadvlei is the white clay bed of an ancient lake. The acacia trees, which must have taken root when there was still moisture, some 900 years ago, are all dead, their sun-scorched wood preserved in the dry atmosphere. 'I had selected my perfect tree a few years ago,' says Marsel, 'and worked out my camera settings.' So then it was a matter of gambling when fog might roll in. On the day that early-morning fog was predicted, he arrived in the dark and set up ready to take the picture at dawn, as the light was just touching the dunes but before the sun made it all too bright. To illuminate the tree he set up a flashlight just behind the trunk – so the light would radiate from its arms in exactly the way he wanted – and then let the fog that rolled in do the rest.

Nikon D4 + 24-70mm f2.8 lens; 15 sec at f8; ISO 400; Gitzo tripod + Markins ballhead; Surefire UB3T Invictus flashlight.

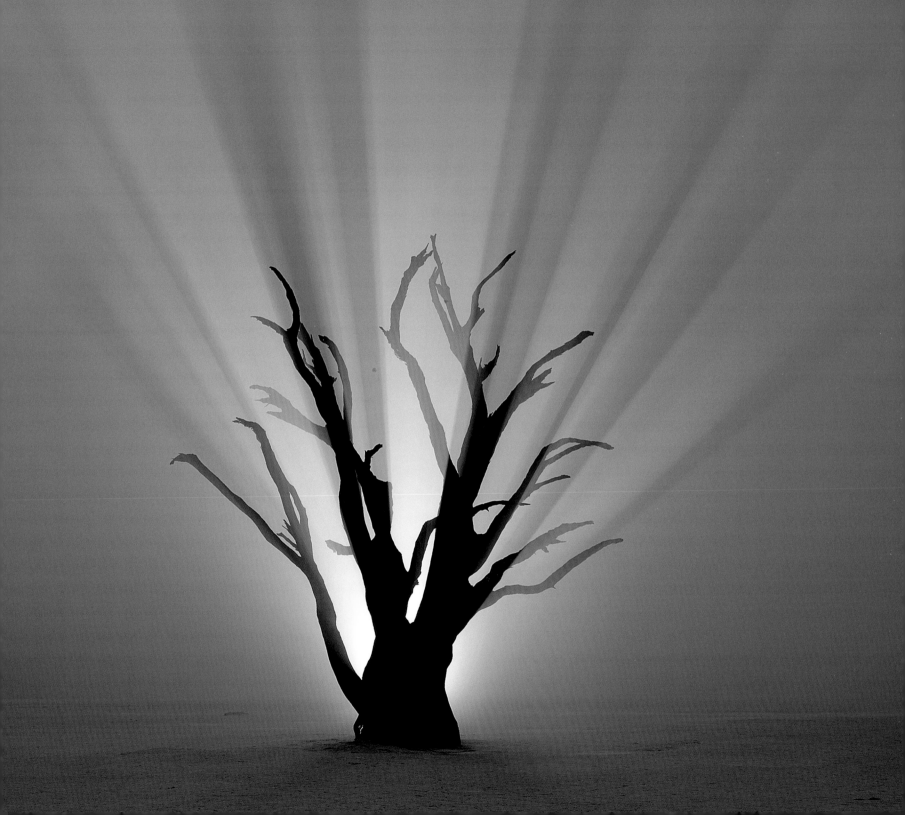

Seen through spruce

COMMENDED

Jérémie Villet

FRANCE

After an unforgettable summer encounter with a male ibex in the French Alps, Jérémie returned in winter to the same mountain spot, in Haute Savoie, to watch the clashing of horns in the rut. Setting off before sunrise and laden with camera equipment, he laboured up the slopes on snowshoes. 'It was a difficult climb,' he says, 'and it was several hours before I came across an ibex.' After a morning chasing females and seeing off other males, the large male was as exhausted as Jérémie, and settled down to rest under the cover of low-hanging spruce trees. It was a very different view of the powerful animal from the one Jérémie had come for, and he was struck by the way it merged with its environment. He watched it for a time and decided on a picture that would reflect the intimacy of the encounter.

Canon EOS 5D Mark III + 500mm lens; 1/3200 sec at f4.5; ISO 320; Velbon monopod.

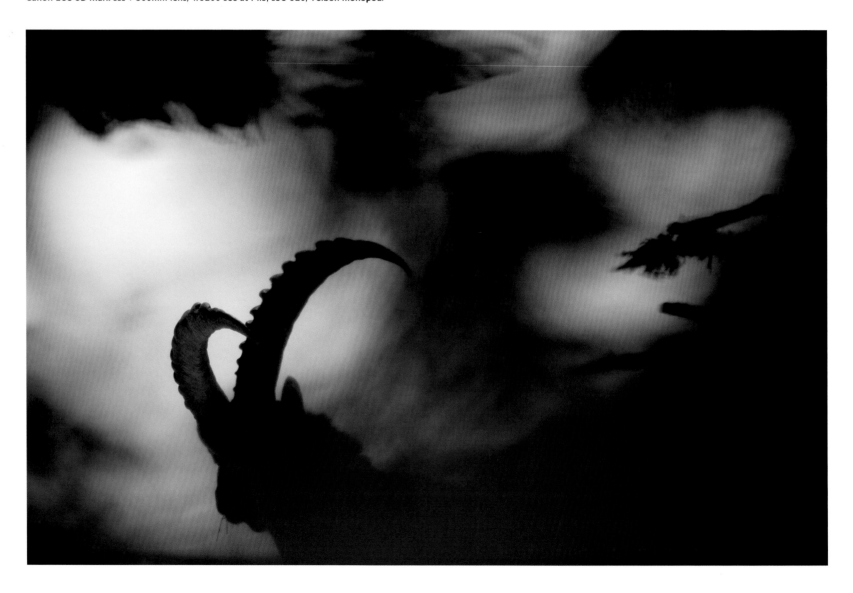

Impression of Africa

COMMENDED

Uge Fuertes Sanz

SPAIN

It was Uge's first trip to Africa. Settled beside a waterhole in Namibia's Etosha National Park, with a wealth of wildlife coming to drink close to where he was parked, it took him a while to decide what to work on. 'Finally,' he says, 'I released the frustrated painter in me' and concentrated on creating an impressionistic picture. Deciding on the structure of the composition, he waited many hours for a combination of animals that worked (finally, the galloping zebra, though there is also an oryx in front). 'The challenge', he explains, 'was making an elephant a foreground frame to a moving background,' as was getting the light exactly right without burning out the image. He took hundreds of pictures and, after eight hours of trying, he finally achieved satisfaction.

Canon EOS 7D + Sigma 50-500mm f4-6.3 lens; 1/20 sec at f32; ISO 100; Opticron window tripod.

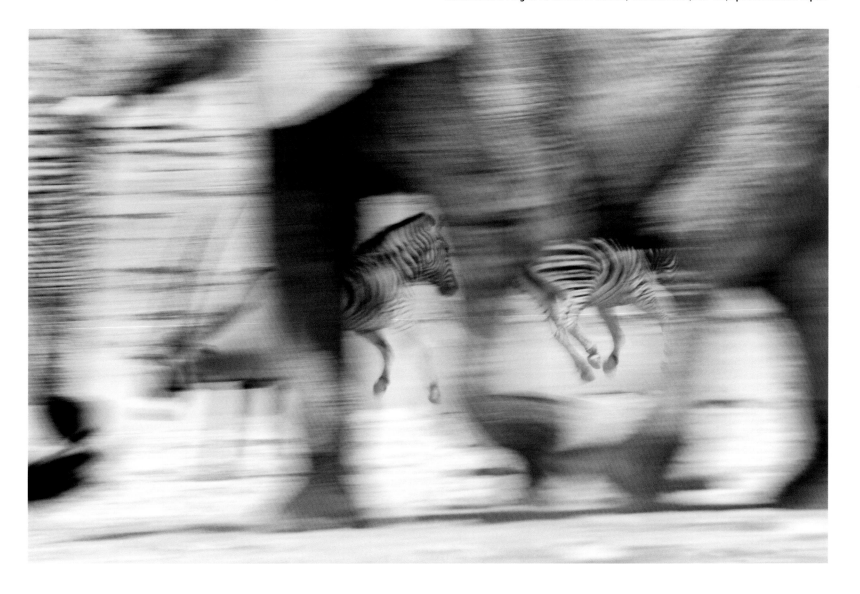

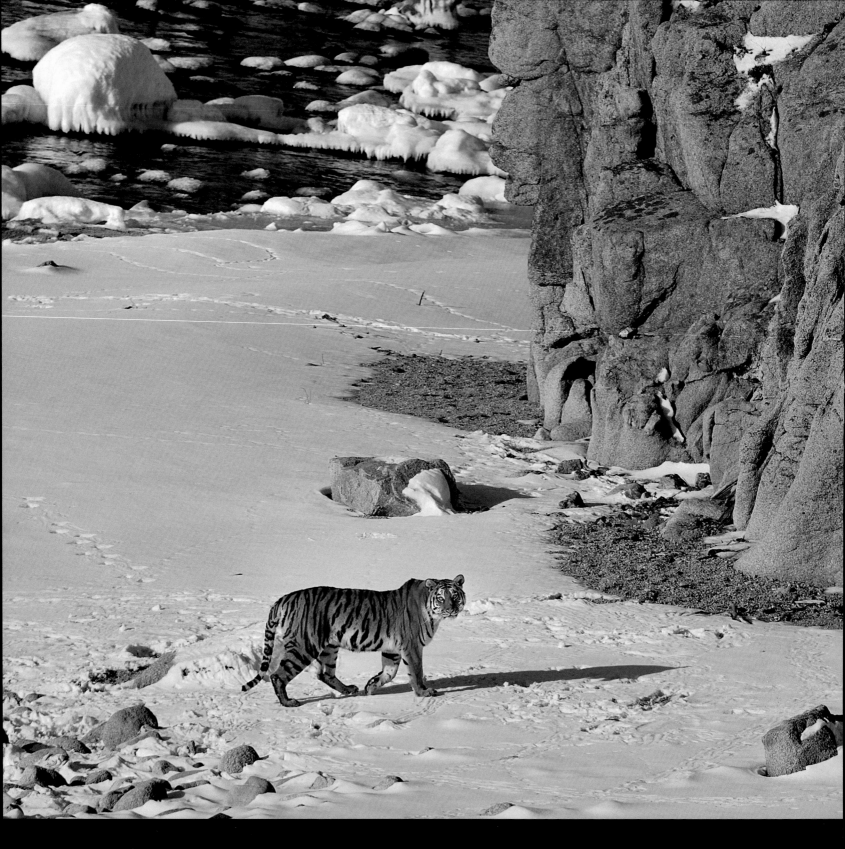

The Gerald Durrell Award for Endangered Species

The purpose of the award, named after the legendary conservationist Gerald Durrell, is to highlight, through photographic excellence, the plight of wildlife under threat. Species featured are officially listed by IUCN as critically endangered, endangered, vulnerable or near threatened.

Tiger untrapped

WINNER

Toshiji Fukuda

JAPAN

This picture of the endangered Amur, or Siberian, tiger is one of only a very few taken in the wild without the use of a camera trap. It's also almost certainly the best – the reward for spending months in a cramped hide. Toshiji has been photographing wildlife in the Russian Far East for more than 20 years, and he knows how hugely difficult it is to see an Amur tiger in its woodland habitat. So when he heard that tiger tracks had been found on the shore of the Sea of Japan in Russia's Lazovsky Nature Reserve, he knew this was his chance. The enticement was sika deer, driven by hunger to feed on seaweed on the shore. Toshiji's Russian colleague dug a hole into the steep slope overlooking the beach and in it built a tiny hut. There they lived, in cold, cramped boredom, for the next 74 days. Occasionally, at night, Toshiji heard growling, and was glad of an electric fence around the hut. But he knew that the chances of seeing a tiger in daylight were slim. Of the 300 or so Amur tigers left in the wild – under constant pressure from poaching and forest destruction – no more than 12 inhabit the reserve. On day 50, he was woken by crows screeching in alarm. The clouds had cleared; it was a beautiful, sunny morning. And there, just 150 metres away, was a tiger. 'The scene was divine – it was as if the goddess of the Taiga had appeared to me.' That was the only time he saw the female, but she allowed him to achieve his lifelong dream, to photograph a wild Amur tiger.

Nikon D3 + 200-400mm lens; 1/1600 sec at f9; ISO 220.

Survivors

RUNNER-UP

Valeriy Maleev

RUSSIA

Valeriy spent 10 days in spring camped in Kedrovaya Pad Nature Reserve, in the Primorskiy Krai region of the Russian Far East. It's a UNESCO biosphere reserve, famous for being home to Amur tigers and leopards. Valeriy's aim was to encounter an Amur leopard, confident that, in his hide on a raised platform, he was safe and the leopard wouldn't feel threatened by him. More of a concern was the Siberian temperature – an average -20˚C in early spring – together with the fact that the leopards were only ever active from dusk. This made it difficult to know when one was actually close to his hide, which doubled as his sleeping tent. Valeriy's plan was to keep focused on an area around a deer carcass he'd dragged up and positioned near a path known to be used by at least one leopard. For a single leopard to appear would have been reward enough, but to see a mother with three cubs (one cub is the norm), before nightfall, was extraordinary. 'I tried to make the most of the fast-fading light,' says Valeriy, 'and I simply couldn't believe my luck when I managed to photograph both the mother and two of her cubs.' The sobering thought, though, is that the family probably represents 10 per cent of the wild population of this officially critically endangered subspecies, which continues to be threatened by habitat loss, fires, poaching and inbreeding.

Nikon D2Xs + 70-200mm f2.8 lens; 1/60 sec at f3.8; ISO 500; Manfrotto tripod.

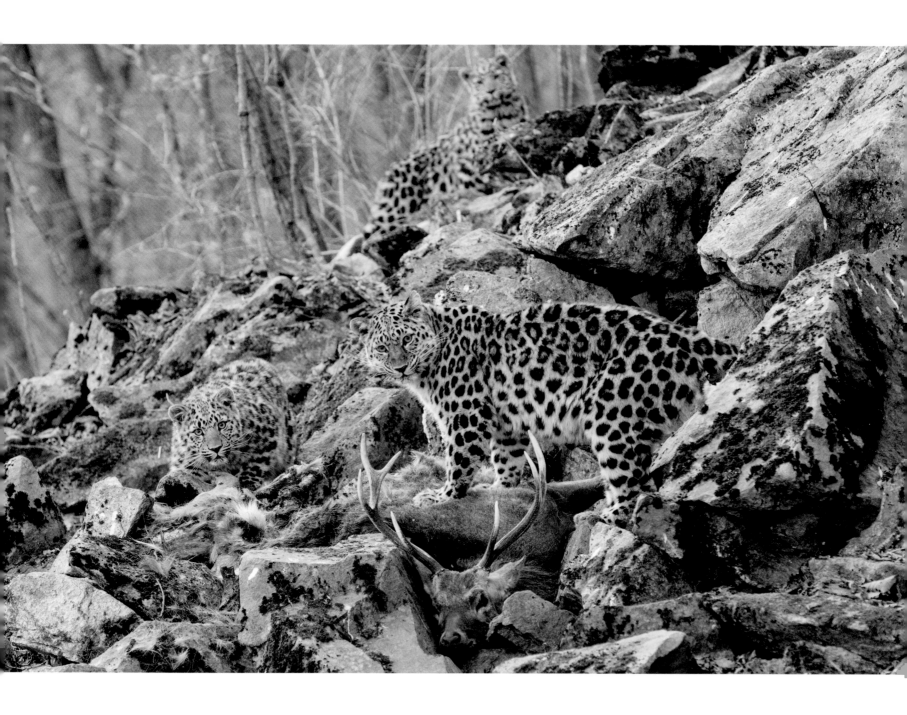

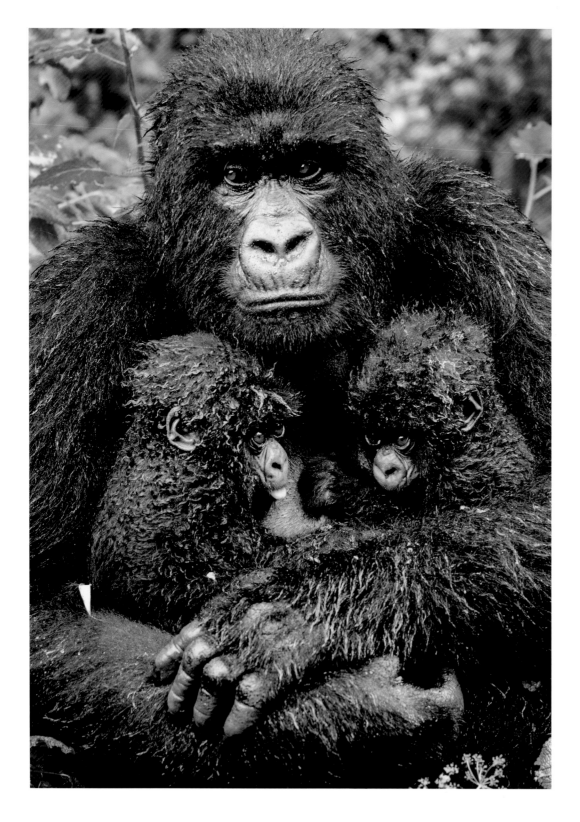

Twin hope

COMMENDED

Diana Rebman

USA

The hike to the mountain gorillas was particularly arduous that day. 'Consistent rain made the ground very slippery,' says Diana, 'and the hillside was so steep it felt vertical.' The gorilla group ahead finally settled to feed. 'What made all the physical effort worth it was to see the mother with her two babies.' This is only the fifth set of twins ever to be reported in Rwanda's Volcanoes National Park. The mother was a natural with her six-month-old infants, nursing them while feeding herself. When the silverback leader of the group chased her from a nettle patch, she vocalised at him, loudly, but moved on. 'In this picture, she is still tense from the encounter', says Diana, 'and continues to glance across at him while she eats. Her twins, in the comfort of their mother's strong arms, appear blissfully ignorant.' The twins' future, though, remains uncertain. The mountain gorilla is officially listed as critically endangered. Habitat loss, poaching and disease are still threats, and the gorillas are also at risk from warring rebel factions active in their range, affecting not only the animals but also the rangers and the tourism revenue that funds their protection.

Nikon D7000 + 70-200mm f2.8 lens; 1/160 sec at f5 (-0.3 e/v); ISO 1600.

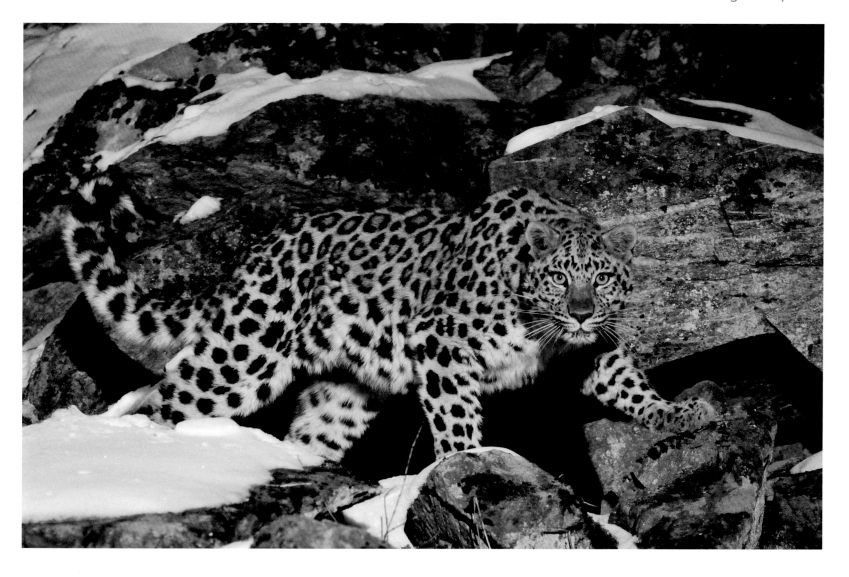

Last look

COMMENDED

Vladimir Medvedev

RUSSIA

Vladimir has spent many years in Kedrovaya Pad Nature Reserve in the Russian Far East tracking Amur leopards. He became familiar with the territory of this female (one of only about 40 leopards remaining) and built a hide in a tree overlooking a regularly used path. Once she was used to it, he set out bait (a deer carcass). The winter cold – regularly -28°C – was a challenge, as were her nocturnal habits. But he wanted snow in the background, and the leopard was bolder at night and got used to the lights he set up around the bait. The two months of preparation and waiting were worth it. 'I'll never forget looking into the leopard's eyes only a few metres away. My hands shook with excitement, and I had to will myself to calm down,' says Vladimir. 'To let this leopard go extinct in the wild would be an unthinkable tragedy.'

Nikon D300 + 80-400mm lens; 1/80 sec at f4.8; ISO 2800; 2x 6500K Xenon studio lamps.

Here a sense of place and atmosphere is all-important, conveying an impression of how an animal is an integral part of its environment.

The water bear

WINNER

Paul Souders

USA

The fact that most images of polar bears show them on land or ice says more about the practical difficulties faced by humans than it does about the bears' behaviour. With adaptations such as thick blubber and nostrils that close, polar bears are, in fact, highly aquatic, and they spend most of their time hunting seals on sea ice and are capable of swimming for hours at a time. Paul took his Zodiac boat to Hudson Bay, Canada, in midsummer to rectify this bias. He scouted for three days before he spotted a bear, this young female, on sea ice some 30 miles offshore. 'I approached her very, very slowly,' he says, 'and then drifted. It was a cat-and-mouse game.' When the bear slipped into the water, he just waited. 'There was just a flat, world of water and ice and this polar bear swimming lazily around me. I could hear her slow, regular breathing as she watched me below the surface or the exhalation as she surfaced, increasingly curious. It was very special.' The light was also special, but for a sinister reason. The midnight sun was filtered through smoke from forest fires raging farther south, a symptom of the warming Arctic – the greatest threat facing the polar bear. As more and more sea ice melts earlier and earlier every spring, it becomes harder for the bears to hunt the seals they depend on.

Canon EOS 7D + 10-22mm f3.5-4.5 lens; 1/320 sec at f4; ISO 400; Manfrotto light boom + cable release.

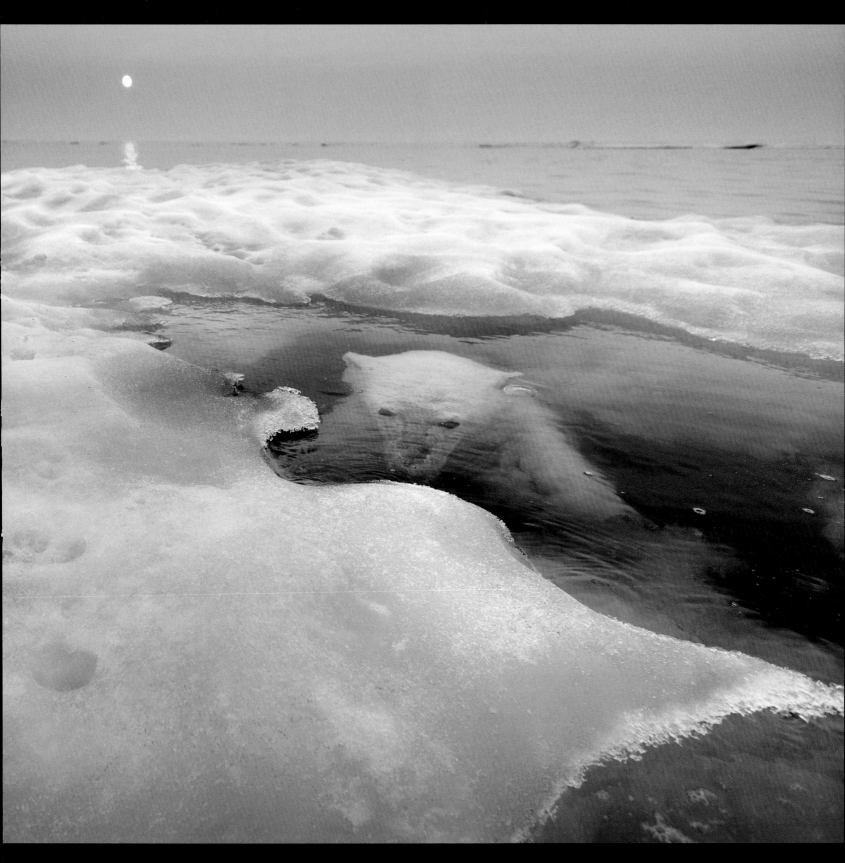

Surfing delight

RUNNER-UP

Wim van den Heever

SOUTH AFRICA

Wim began to regret setting out in such a small boat that day. His tough-plastic camera bags were leaking salt water onto his precious camera, the heavy swell made it a challenge to balance, and he had painful cramp in his arm from holding the heavy lens to his eye. 'I had to concentrate hard', Wim says, 'on keeping the dolphins in the viewfinder while not falling out of the boat.' But the moment the mass of bottlenose dolphins exploded in unison, he knew it was all worth it. The perfect backdrop for such a serendipitous moment was the backlit curtain of sparkling spray. Some scientists argue that dolphins don't play for the sheer fun of it in the way we humans do. What Wim observed that day off Port St Johns, South Africa, suggests otherwise.

Nikon D4 + 200-400mm f4 lens; 1/3200 sec at f8 (-0.7 e/v); ISO 1000.

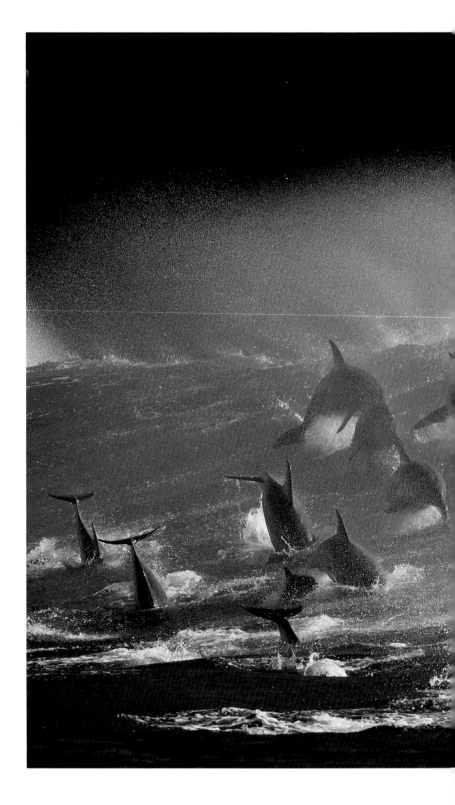

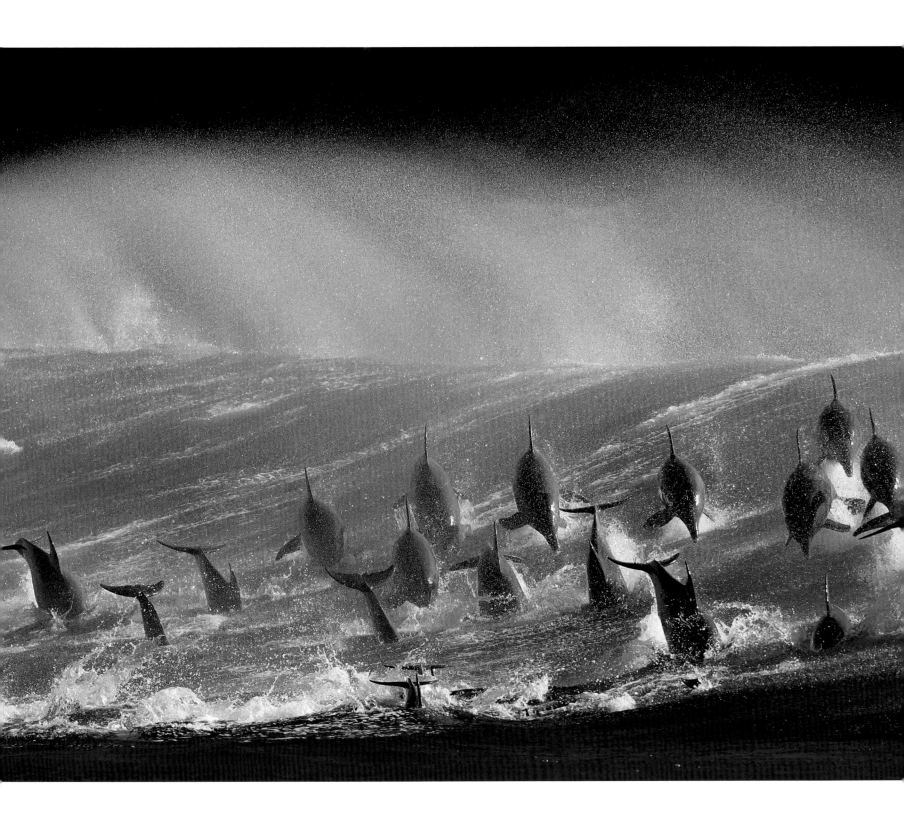

Little bird, big water

SPECIALLY COMMENDED

Alessandro Bee

ITALY

Alessandro spent a week in Argentina photographing the magnificent 80-metre cascades of the famous Iguaçu Falls. Early one morning, he became aware of white-eyed parakeets flying back and forth in front of the cascade and over the top of the falls. It was a mystery what they were doing, but he became fascinated by them and spent the next few hours trying to capture a shot as the birds flew daringly close to the pounding water. 'I wanted to highlight the striking contrast between the raw power of the falls and such an elegant little bird, looking so vulnerable against the thundering water backdrop.'

Nikon D3s + 80-200mm f2.8 lens; 1/1000 sec at f7; ISO 200.

On top of the world

COMMENDED

Jérémie Villet

FRANCE

Jérémie grew up on a farm in the countryside near Paris, France, and his childhood dream had been to climb mountains and see a wild Alpine ibex. Each year, he went with his family skiing in the French Alps. But last summer, he went to the Alps specifically to look for ibex. He set off on the four-hour climb in good time to catch the sunset, but a thick fog meant it took him several more hours to reach the summit. 'When I emerged from the clouds,' says Jérémie, 'it was like entering a new world.' But the real surprise was to see below him a male ibex. 'It was more than I'd hoped for', says Jérémie. 'Just me and the ibex and the beauty of the Alpine scene.'

Canon EOS 7D + 28-75mm f2.8 lens; 1/160 sec at f2.8 (-0.7 e/v); ISO 320.

Storm panic

COMMENDED

Gregoire Bouguereau

FRANCE

As a storm began to brew, this group of males in the Serengeti National Park, Tanzania, got more and more agitated. 'I have often observed elephants getting very restless when weather conditions are unstable, and particularly in strong wind,' says Gregoire, 'and this storm turned into an extreme one.' A sudden gust foreshadowing what was to come reached the small group. 'The elephants immediately started to trumpet in panic,' says Gregoire, who took this picture when the agitated giants, caught in the rising sandstorm, fled in front of his vehicle.

Nikon D800 + 16-35mm f4 lens; 1/400 sec at f11 (-0.7 e/v); ISO 200.

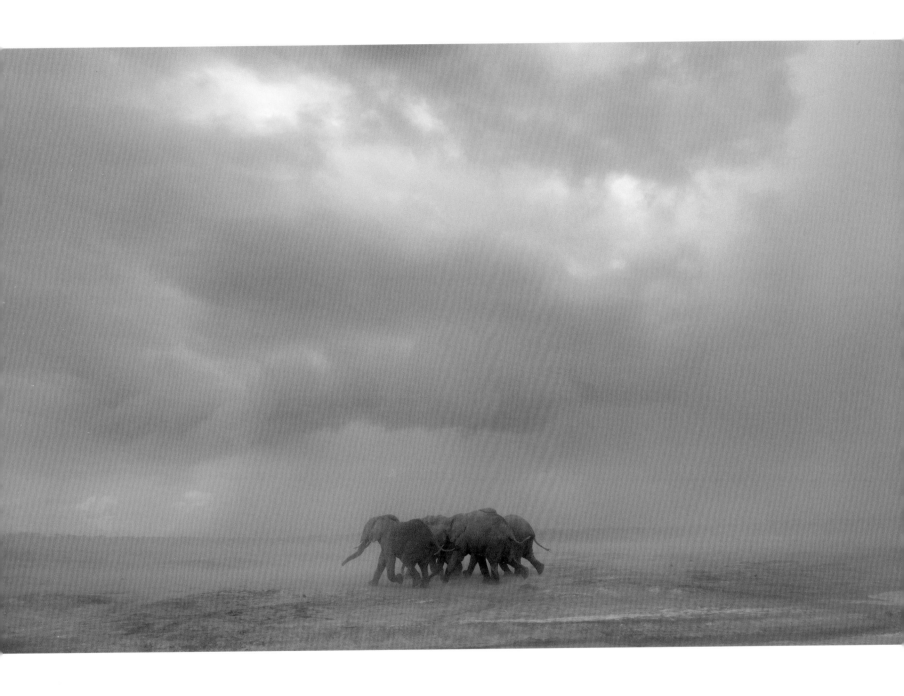

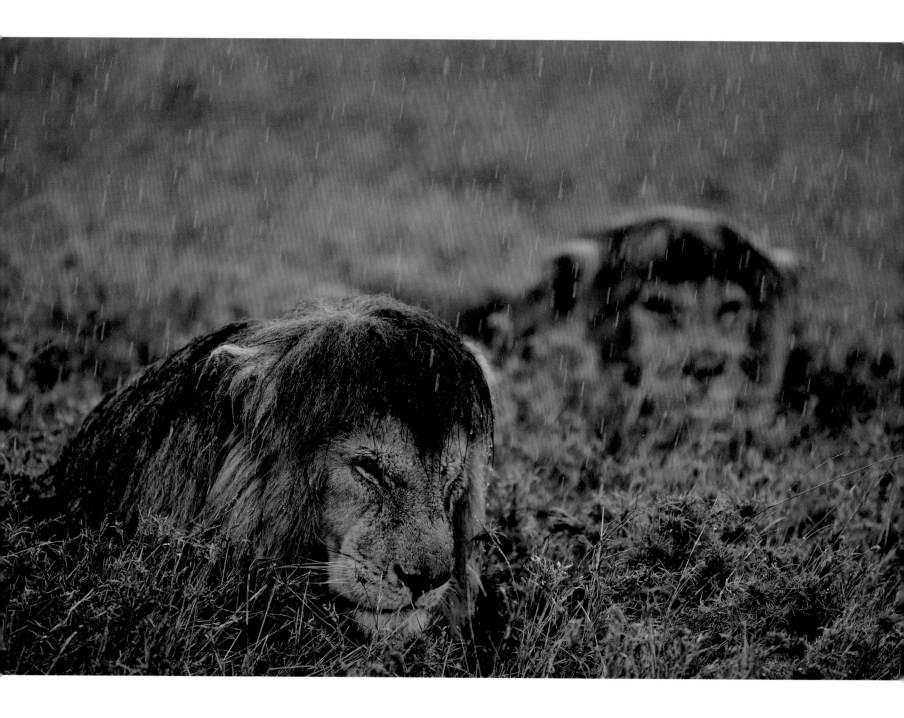

Sharing a shower

COMMENDED

Michael 'Nick' Nichols

USA

Scientists have long thought that the main reason that lions band together is to hunt – that food, essentially, is the evolutionary force behind their social bonds. Recently, though, it has emerged that the close bonds between males are moulded by another pressure: the actions of mutual rivals. C-Boy, a black-maned male lion, and his coalition partner Hildur, once controlled a superior territory in Tanzania's Serengeti National Park, but they were deposed by a squad of four males known to researchers as the Killers. Nick came across C-boy and Hildur hunkered down in the rain. Though he had spent many months photographing Serengeti lions, he had spent most of his time with larger prides of females. 'I had never before seen these two senior coalition males together,' he says. They were used to the car that Nick was in, so he was able to use a simple zoom lens and ambient light. The rain isn't as unwelcome as their expressions suggest: when water is scarce, the closely bonded pair lick drops from their own and each other's fur.

Canon EOS-1D X + 70-200mm f2 lens; 1/350 sec at f2.8; ISO 400.

Snowbird

COMMENDED

Arto Raappana

FINLAND

It was January, and Arto was in the Torne River Valley, 10 kilometres inside the Arctic Circle in northern Finland. 'There are many challenges for a photographer in winter,' says Arto. 'There is limited daylight, the hilltops are illuminated only briefly and the temperature can be -40°C. I wanted to show the birds surviving in this harsh habitat.' There had been heavy snow and frost for a couple of months, which made photography particularly gruelling and time-consuming but provided wonderful hoar-frost textures and designs. Using bird food as bait, he concentrated on one particular great tit in its frozen forest home. 'It took a long time to get the shot, standing in the raw cold,' adds Arto, 'but finally I managed to immortalise the little bird with its wings in the perfect position and with the snow-sculpted, frost-encrusted trees as I wanted them.'

Canon EOS-1D Mark IV + 24-105mm f4 lens; 1/1250 sec at f4 (+2.3 e/v); ISO 2000.

The World in Our Hands Award

Here the challenge is to show our interaction with the natural world and create awareness of how those actions can affect it. Whether graphic or symbolic, it should be thought-provoking and memorable.

The fish trap

WINNER

Mike Veitch

CANADA

Whale sharks are the largest fish in the sea, but they are filter-feeders eating mostly plankton and small fish and, according to received wisdom, rarely interact with humans. So when whale sharks were filmed vacuuming up bits of fish from nets in Indonesia, it caused an internet sensation. But it seems that this behaviour is hardly new. 'The fishermen around the islands have known about this for ages,' says Mike. Their nets hang from fishing platforms on their boats, and the night lights set to attract silverside baitfish to them also attract whale sharks, which have learned to suck up the fish from the drop-nets. The fishermen don't begrudge them, regarding them as good luck. Now they really have brought luck. Divers and snorkellers are travelling here specifically to interact with the sharks, and dive companies, fishermen and local villages are recognising the economic potential. Mike took this image of a sub-adult (about six metres long) in Cenderawasih Bay, Papua, Indonesia. 'I wanted to show the whale shark actively sucking on the net – a learned behaviour,' he says. 'What's not clear is whether the sharks risk becoming dependent on this food source. It shows just how powerfully humans can impact the behaviour of wild animals,' though it is deliberate and accidental net entanglement that is the real danger to whale sharks.

Nikon D90 + Tokina 10-17mm lens at 14mm; 1/80 sec at f7.1; ISO 200; Aquatica housing.

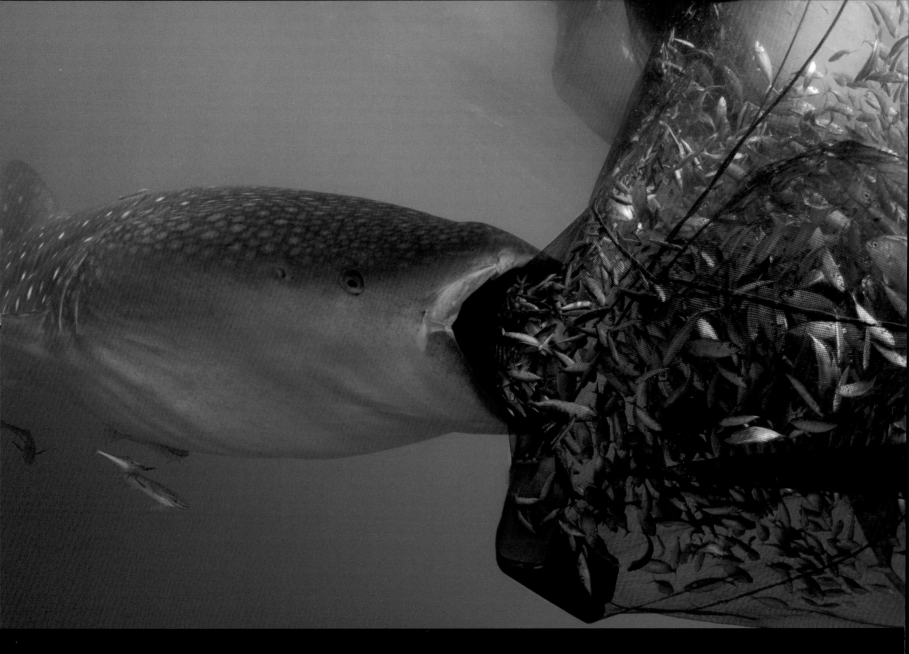

Oil spoils

RUNNER-UP

Garth Lenz

CANADA

To portray the sheer scale of the Alberta tar sands in Canada, Garth took to the skies. 'One of the biggest challenges', he says, 'was directing the pilot to position the plane precisely for the optimal composition. Multiple passes were required to get the positioning just right.' Garth's aim was for the public to see his pictures and grasp the scale of the devastation. This scene is just a small section of one of five huge tar-sand mines in the region. Tar sand is a mix of clay, sand, water and bitumen – a heavy, viscous oil, which needs refining. To extract the bitumen, wilderness areas the size of small countries have been replaced with toxic lakes, open-pit mines, refineries and pipelines. Huge quantities of oil (more than two trillion barrels) are locked up in tar sands and offer a viable way to cope with the world's energy needs, but at a huge cost. Putting aside the massive loss of wildland and the water pollution issues, tar sands are considered to be the most carbon-intensive form of energy, and as former-NASA-climatologist James Hansen has stated, if the tar sands are fully tapped it will be 'essentially game over' for any hope of establishing a stable climate.

Nikon D3 + 24-70mm f2.8 lens; 1/800 sec at f6.3; ISO 800.

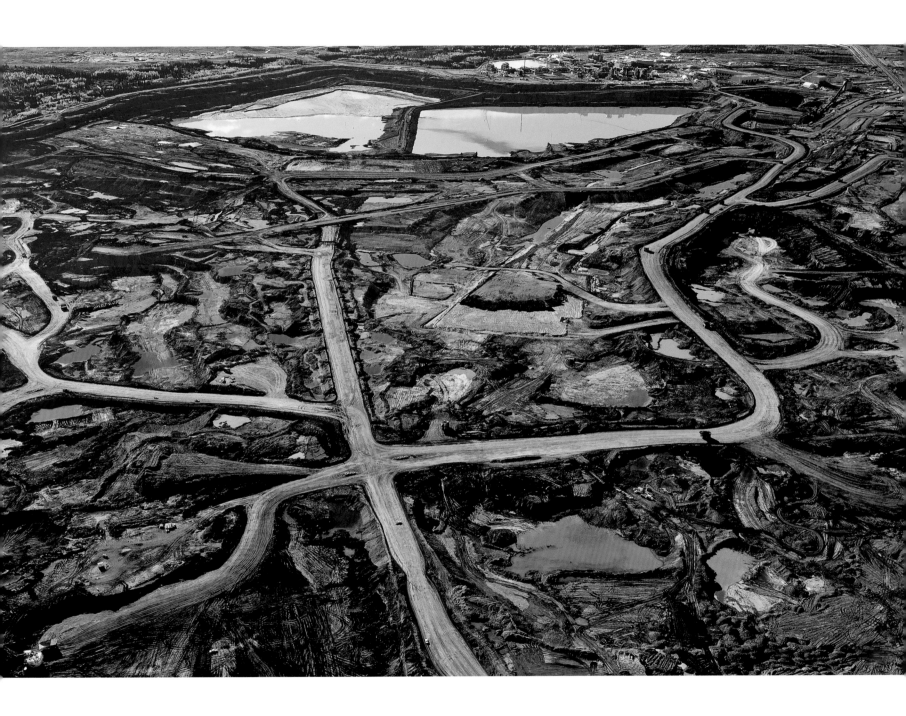

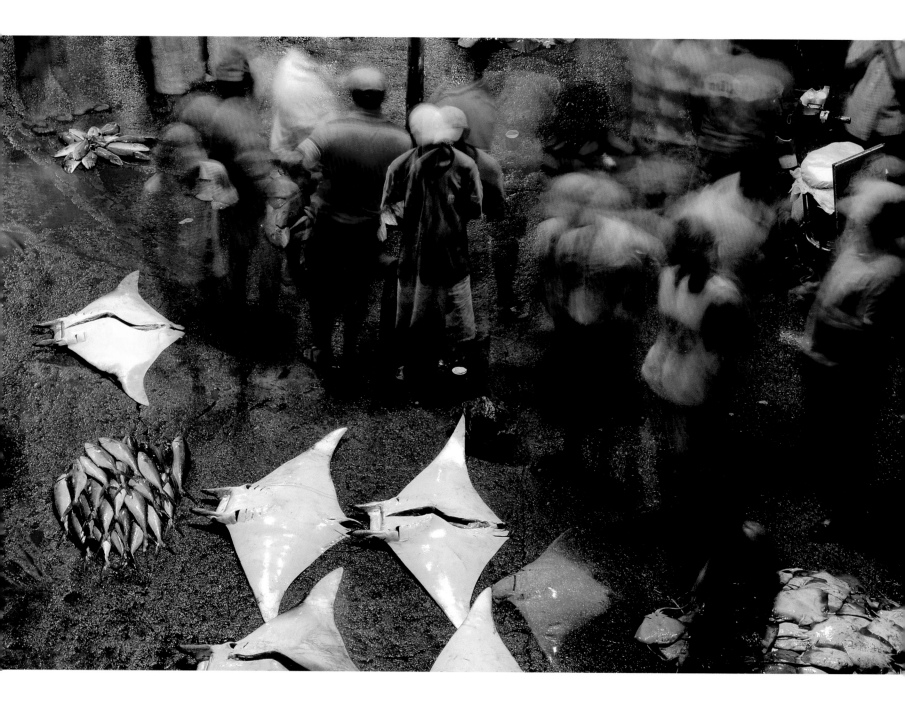

Death rays

SPECIALLY COMMENDED

Thomas P Peschak

GERMANY/SOUTH AFRICA

Manta rays and their smaller cousins, mobula rays, have until recently escaped the ravages of major fisheries, as their flesh has always been regarded as poor quality. But in recent years, the feathery gill rakers of the filter-feeding rays have become highly desirable in the Chinese medicine trade, often consumed in soup, like shark fins. The soaring value of the rakers has resulted in massive, unsustainable catches in Mexico, Thailand, Indonesia and Sri Lanka, which is where Thomas took this photograph. Climbing onto the roof of a fish market, he used a long exposure to blur the moving crowd of traders while keeping the mobula ray carcasses in sharp focus. These ancient animals are slow breeders – a female might not mate until she is 15 years old and might give birth to only 10-16 pups in a 40-year lifetime, if she avoids being caught. The problem is that as surface feeders, rays are easy to spot, and because of their habit of aggregating in huge groups in regular feeding places or at cleaning stations, whole populations are easily wiped out. Conservationists see ecotourism as one way of giving a different value to coastal ray populations and see publicity for their rapid decline as vital if fisheries are to be regulated.

Nikon D700 + 24-70mm lens; 25 sec at f22; ISO 320; tripod.

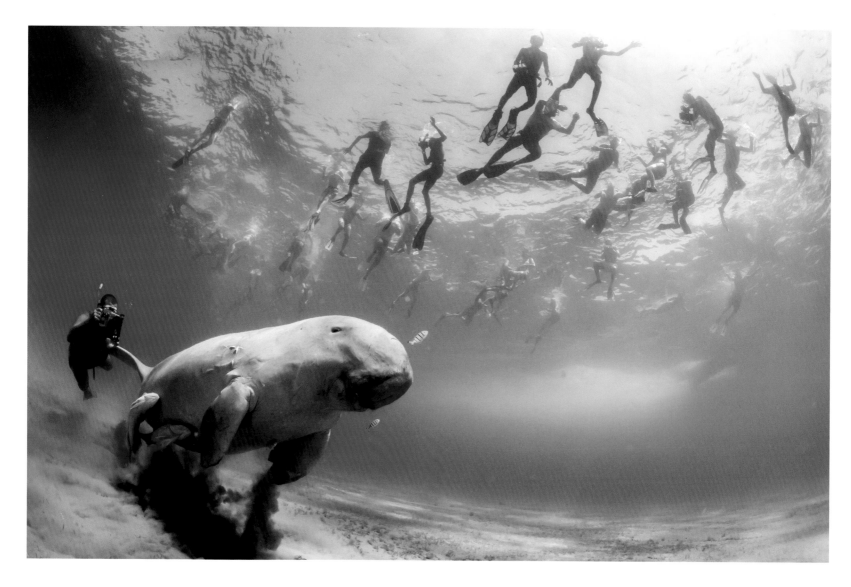

The pull of a dugong

COMMENDED

Douglas Seifert

USA

When a dugong is feeding in the bay of Marsa Alam, Egypt, snorkellers flock to see it. On this occasion, Douglas found himself watching the snorkelers as more and more of them hassled it until it fled for the open sea. These tourists would undoubtedly agree that without dugongs the world would be a poorer place, but without control of the numbers and behaviour of snorkellers and divers, they only add to the pressure faced by the dugongs, just seven of which are known to live along the 100km coastline. The real problem is urbanisation of the coast, which is destroying the seagrass beds the dugongs depend on. What is urgently needed are controls on development and recognition of the value of the dugongs to tourism.

Nikon D800 + 15mm fisheye f2.8 lens; 1/320 sec at f16; ISO 640; Nauticam housing; two INON z-220 strobes.

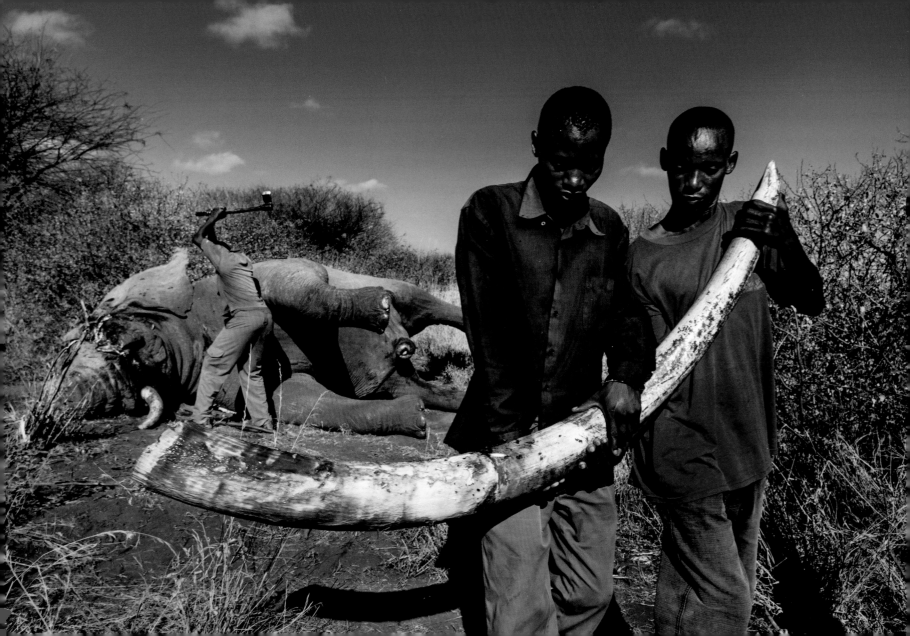

Ivory trash

Possibly the largest mass killing of elephants in recent history took place early in 2012 in the Bouba Ndjida National Park in north Cameroon, close to the Chad and Central African Republic borders. A group of 100-200 men entered the park on horseback, armed with rocket-propelled grenades, light machine guns and AK47s. Small teams of riders then herded the elephants together before shooting every single one, including tuskless babies. Groups of up to 64 elephants were gunned down together. The poachers told local villagers that they had killed more than 650 elephants in the 500,000-hectare region, and more than 500 kills have been confirmed. 'These weren't local poachers,' says Brent. 'They were highly organised, and their leaders were rumoured to be from north Sudan.' There are reports of the same group operating in other countries, and so they appear to be crossing borders with ease. Here, a village ranger examines piles of corpses. Their faces were missing, but he recognised them nonetheless, as these were animals he had worked with for more than 20 years.

Canon EOS 5D Mark II + 16-35mm f2.8 lens at 19mm; 1/250 sec at f5.6; ISO 400.

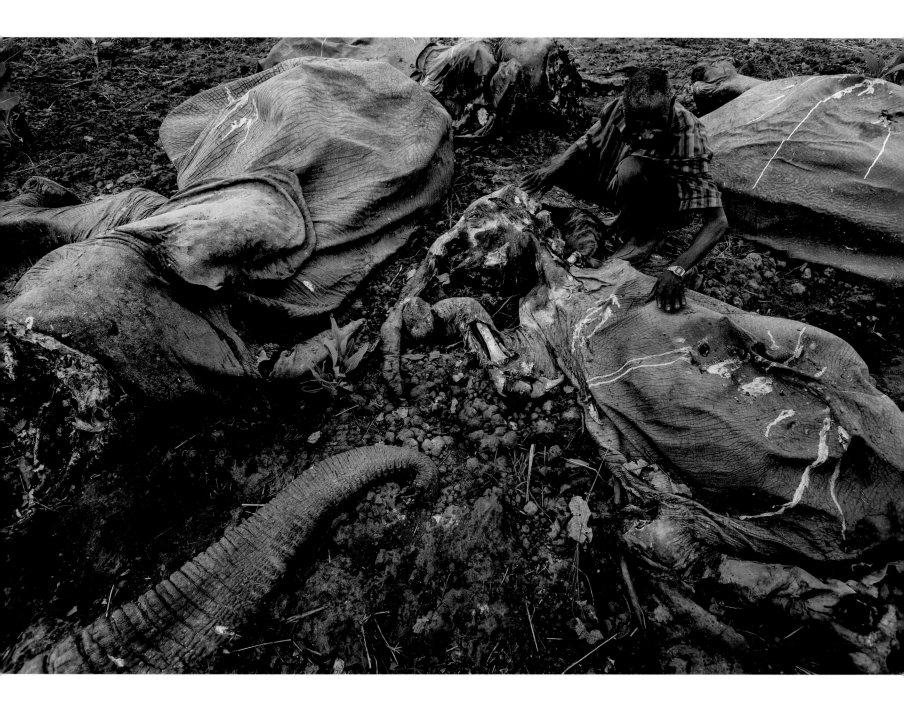

A traditional killing

The world's largest ivory-carving factory in Beijing employs more than 40 full-time artisans who carve an alleged 750kg of raw ivory annually. According to the director, it was launched in 2009, after China's last big legal purchase of African ivory, as a state initiative against the demise of the ivory-carving industry. 'Ivory carving is seen as an ancient art, and the carvers' skills something to be proud of,' says Brent. 'But it is also hugely profitable – the business is worth half a billion dollars worldwide annually, and the few people who profit the most don't want this tradition to end.' Here, a carver from China's National Arts and Crafts Corporation works on a large ivory tusk depicting a Buddhist symbol for prosperity. China is considered to be the biggest importer of illegal ivory. The consumers buy for the dual purpose of investment and the promise of good fortune.

Canon EOS 5D Mark II + 16-35mm f2.8 lens at 20mm; 1/60 sec at f4.5; ISO 1000.

Blessed profits

Thailand's ivory laws are riddled with loopholes as a result of a legal domestic market, and the country is suspected of being a major transit point for illegal African ivory going to China. A big part of the domestic trade is the sale of religious icons. The highly influential head abbot of Wat Suan Paa Phutthasatharn Supraditme Thee Temple wears ivory carvings of Buddhist icons. The temple sells these on to his followers, who are prepared to pay well for a blessed icon. The abbot has spoken openly about the presence of illegally imported African ivory and talked about senior members of the Thai parliament being behind the industry and the business opportunities for illegal ivory entering the country. He also heads a public relations campaign for a centre for Asian elephants in Surin. 'This abbot has followers all around the world,' says Brent. 'He could, if he chose to, be a real force for good.'

Canon EOS 5D Mark II + 16-35mm f2.8 lens at 18mm; 1/250 sec at f5; ISO 400.

From tooth to totem

Master carver Marcial Bernales has been carving ivory for 45 years. From his workshop in Valenzuela, near Manila in the Philippines, he has made hundreds of pieces, all of which are of a religious nature, depicting Catholic images. His work is in the collections of many devotees, and his ivory pieces – such as this one of an ivory head and hand set – are in great demand among the wealthy collectors of the Philippines and abroad. He and his wife, who co-runs the workshop and their shop in Manila, claim to use only pre-ban ivory, but that is questionable, given the demand and the fact that the Philippines has never been the recipient of any post-ban legal ivory sale. In June 2013, Filipino authorities destroyed a huge haul of illegal ivory shipments, to show to the world that it intends to crack down on the illegal trade.

Canon EOS-1D Mark IV + 16-35mm f2.8 lens at 16mm; 1/125 sec at f2.8; ISO 1250.

The end of elephants

Most of the pieces in this Filipino man's collection are carved almost entirely out of ivory, and some are probably worth up to US$30,000. Most were carved in the past six years, allegedly from pre-ban ivory. The man belongs to an emerging group of wealthy, devout collectors in the Philippines, who search out and commission new carved ivory work. Their acquisitions are of huge importance to them, both spiritually and materially, saturated as they are in layers of meaning and value as protective icons, fashion accessories, investments and heirlooms. The patronage and obsession of such wealthy collectors sustains the trade in illegal ivory, creating an inevitable threat to elephant populations worldwide. The harder it is to come by, the greater the value of ivory, and the demand accelerates – a divine investment.

Canon EOS-1D Mark IV + 35mm f1.4 lens at 35mm; 1 sec at f20; ISO 400.

The last tree

It has been estimated that to build Belo Monte, the amount of earth and rock movement is more than was moved to build the Panama Canal. Here, mounds of construction material mark the progress of canal excavation. A dead tree – possibly a protected Brazil nut tree, its base burnt – is the last sign that a forest was once here. 'It's impressive to see how the developers ride roughshod over legislation meant to protect the forest and the rights of forest communities,' says Daniel. 'If they don't ignore it, they find loopholes or they just get permission retrospectively.'

Canon EOS 5D Mark II + 70-200mm f4 lens at 122mm; 1/1000 sec at f8; ISO 250.

Discarded

It was the rainy season when Daniel flew over part of the area where one of the Belo Monte dams will be built. In some floodplains, shallow water prevented construction vehicles from reaching and removing the felled trees. So once-mighty trees lie in shallow water like discarded matchsticks. 'The water was so still that I could see the roots in the silvery water,' says Daniel. 'The clouds reflected in the water made it look as though the dead trees were floating up to the heavens.'

Canon EOS 5D Mark II + 70-200mm f4 lens at 70mm; 1/1000 sec at f4.5; ISO 250.

The nature of destruction

These trees are about to become piles of logs as the work continues to clear vast tracts of rainforest to make way for one of the Xingu River dams. Plans have faced controversy at every stage, but have gone ahead in spite of bitter opposition and trenchant criticism from national and international experts, including human rights groups, lawyers, environmentalists, politicians and economists. Too much has been invested for the project to be halted.

Canon EOS 5D Mark II + 70-200mm f4 lens at 70mm; 1/1000 sec at f4; ISO 250.

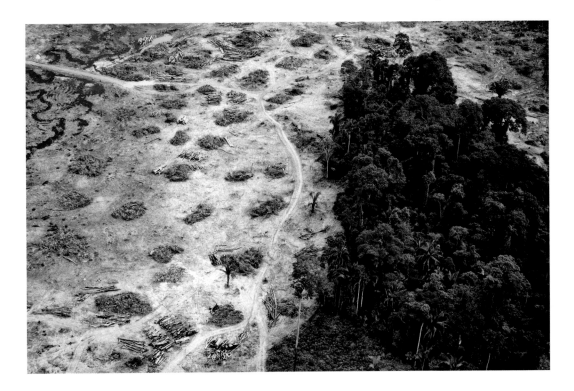

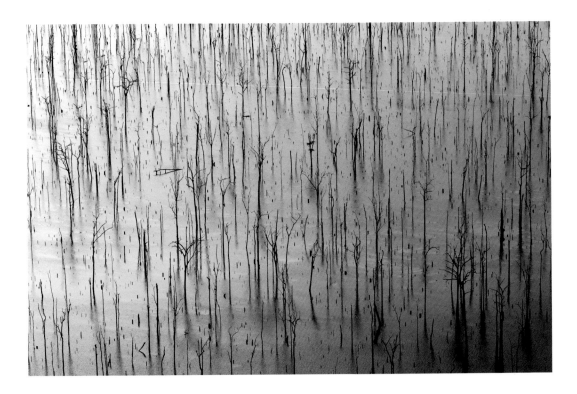

Ghost forest

Trees inundated by the reservoir created from the damming of the Curuá Una River, a tributary of the Amazon, in Brazil's Pará state, tell the story of another lost forest area. 'It's a stark reminder of what the future holds for the vast area that will be affected by the Belo Monte project,' says Daniel. Studies of the reservoir have shown that hydroelectric dams in tropical forest areas emit more greenhouse gases (from decay, mainly) than does the generation of the same amount of energy from oil.

Canon EOS 5D Mark II + 135mm f2 lens; 1/1000 sec at f9; ISO 320.

The Eric Hosking
Portfolio Award

This award seeks to inspire and encourage young and emerging talent.
It was created in memory of the pioneering natural history photographer
Eric Hosking and is given to a photographer between the ages of 18 and 26
for a portfolio of six images.

Connor Stefanison

CANADA

 Living on the Pacific coast of British Columbia, Canada, Connor has learnt about wildlife and wilderness first-hand. He took up photography when he was 17, going on to win a number of scholarships and prizes. Now, at 22, he is finishing a degree in ecology and conservation and is planning to work as a biologist and eventually as a full-time wildlife photographer.

Silent flight

In the past few years, snowy owls have overwintered farther south than usual and – to Connor's delight – in a salt marsh near his home. For about a week, he got up at dawn and drove to the salt marsh, experimenting with various settings that would create an impression of the owls' ghostly flight as they patrolled the fields in search of food. 'At first I was disappointed that I didn't capture the owl head on,' he says, 'until it occurred to me that this shot of it disappearing into the gloom might capture a far more intimate and atmospheric impression.'

Canon EOS-1D Mark IV + 500mm f4 lens at 700mm + 1.4x extender; 1/15 sec at f6.3; ISO 400; Canon 580 EX II flash; Custom Brackets flash bracket; Better Beamer flash extender.

Evening peace

As a boy, Connor had fished the lakes of the British Columbia interior extensively. He knew the great northern divers of this lake and that they were tolerant of people. But on the nest they can be very nervous, and so Connor allowed this female to get used to his presence, wading in a little closer every day, increasing her trust. His patience paid off. She soon totally accepted him, and on one visit even laid a second egg. 'Once I knew she was comfortable with my presence, I spent a few days waiting for the right light and earning more trust. It was a thrill to see her stand up and adjust her eggs, totally relaxed.' Connor wanted to capture the intimacy of the nest scene within the lake setting, and so used a wide-angle, with his camera (camouflaged) on remote. 'It was a once-in-a-lifetime experience and the best I've ever had.'

Canon EOS 5D Mark II + 16-35mm f2.8 lens at 16mm; 0.3 sec at f20; ISO 100; Canon 580 EX II flash + built-in diffuser and white card; Vello FreeWave Plus wireless remote shutter.

The flight path

Connor's photography draws on the wilderness skills he acquired over a childhood spent largely outdoors. This female barred owl had a territory near his home in Burnaby, British Columbia. He watched her for some time, familiarising himself with her flight paths until he knew her well enough to set up the shot. 'I wanted to include the western red cedar and the sword ferns so typical of this Pacific coastal rainforest.' Setting up his camera near one of the owl's favourite perches, linked to a remote and three off-camera flashes, diffused and on low settings, he put a dead mouse on a platform above the camera and waited for the swoop that he knew would come. 'She grabbed the mouse, flew back to her perch and began calling to her mate. It is one of the most exciting calls to hear in the wild.'

Canon EOS 5D Mark II + 16-35mm f2.8 lens at 16mm; 1/13 sec at f8; ISO 1600; Canon 580 EXII flash + Canon 580 EX flash + Canon 430 EX II flash; Vello FreeWave Plus wireless remote shutter; tripod.

Lucky pounce

'Anticipating the pounce – that was the hardest part,' says Connor, who had come to Yellowstone National Park, Wyoming, USA, in search of wildlife as much as the spectacular landscape. He had found this fox, his first ever, on his last day in the park. It was so absorbed in hunting that Connor had plenty of time to get out of the car and settle behind a rock. It quartered the grassland, back and forth, and then started staring intently at a patch of ground, giving Connor just enough warning of the action to come. When it sprung up, Connor got his shot. And when it landed, the fox got his mouse.

Canon EOS-1D Mark IV + 500mm f4 lens at 500mm; 1/2500 sec at f8; ISO 500.

Camouflage

Three black dots – one beak, two eyes – were what Connor was looking for: a ptarmigan in full winter plumage. Having scoped out suitable white-tailed ptarmigan habitat, at 3,000 metres in Jasper National Park, Alberta, Canada, he and his friend, kitted out in mountain gear and snowshoes, were on a long search for the snow-camouflaged bird. After fruitless hours following tracks and droppings and facing into a bone-chilling wind, Connor finally spotted his three black dots. When he realised that the ptarmigan was moving towards sprigs of willow to feed on the buds, he composed his shot, anticipating that the bird would carry on walking into the frame. By placing it at the edge of the frame, the ptarmigan became a hidden bonus in a beautiful snow scene.

Canon EOS 5D Mark II + 70-200mm f2.8 lens at 150mm; 1/125 sec at f7.1; ISO 1000.

Hot-spring magic

Hot springs bubble up through the limestone that was once an ancient inland sea, building a series of shallow, white travertine terraces in the Mammoth Hot Springs in Yellowstone National Park. Cyanobacteria living in the geothermal water tint the travertine in shades of brown, red-orange and green. It was cold on the morning that Connor visited, and thick steam swirled around the dead trees, with their bases engulfed by travertine and snow on their windward sides. Using a long exposure, Connor caught the scene's mystical atmosphere.

Canon EOS 5D Mark II + 70-200mm f2.8 lens at 115mm + Kenko circular polarising filter; 1 sec at f11; ISO 100.

The Young
Wildlife Photographer
of the Year

The Young Wildlife Photographer of the Year 2013 is Udayan Rao Pawar –
the photographer whose picture has been judged to be the most memorable
of all the pictures by photographers aged 17 or under.

Udayan Rao Pawar

INDIA

 **Udayan, a 14-year-old naturalist
and photographer from Madhya
Pradesh, India, grew up surrounded
by wildlife. It was the gift of a
pair of binoculars that turned
him into a naturalist, and then, four years ago,
the gift of a camera with a zoom lens which
transformed his interest into a passion. Udayan
is also passionate about conservation. He lives
within reach of the Chambal River – the last
stronghold of the Indian gharial – and on his
holidays, helps field staff working with this critically
endangered fish-eating crocodile, doing surveys
and collecting eggs for a restocking programme.**

Mother's little headful

One night, Udayan camped near a nesting colony of
gharials on the banks of the Chambal River – two groups
of them, each with more than 100 hatchlings. Before
daybreak, he crept down and hid behind rocks beside the
babies. 'I could hear them making little grunting sounds,'
says Udayan. 'Very soon a large female surfaced near the
shore, checking on her charges. Some of the hatchlings
swam to her and climbed onto her head. Perhaps it made
them feel safe.' It turned out that she was the chief female
of the group, looking after all the hatchlings. Though he
saw a few more females and a male, they never came
close. Gharials were once found in rivers all over the Indian
subcontinent. Today, just 200 or so breeding adults remain
in just 2 per cent of the former range. 'The Chambal
River is the gharial's last stronghold,' says Udayan, 'but is
threatened by illegal sand-mining and fishing.'

Canon EOS 550D + 100-400mm lens; 1/400 sec at f13; ISO 1600.

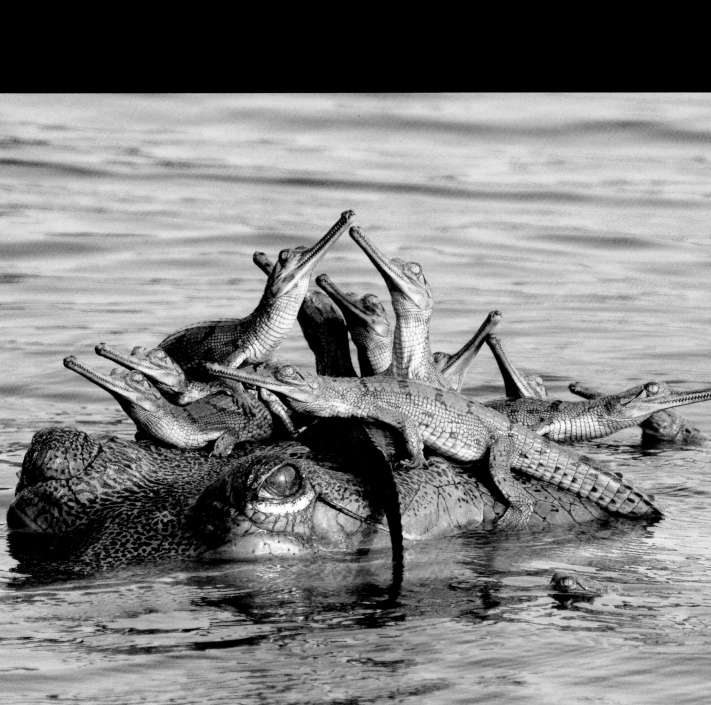

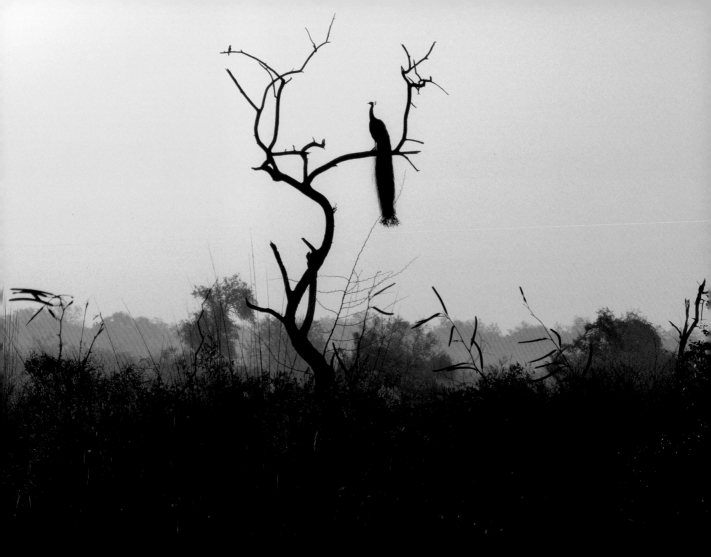

Peacock at sunrise
WINNER (10 YEARS AND UNDER)

Louis Pattyn
BELGIUM

Last year, Louis and his family went on holiday to India with an Indian friend, who took them to lots of nature reserves. 'One morning we went for a visit at sunrise', says Louis, 'to Keoladeo National Park', in Bharatpur. 'There were many peacocks still asleep in the trees. When they woke up, they would fly away' to forage. 'I took my picture just before this peacock left his tree. I really liked the silhouette of the peacock and the tree, also the special light.' It wasn't until Louis looked at the picture later that he saw the second silhouette – as distinctive as the peacock's – a bee-eater.

Canon Powershot G12; 1/2000 sec at f5.6, 0.7; ISO 200

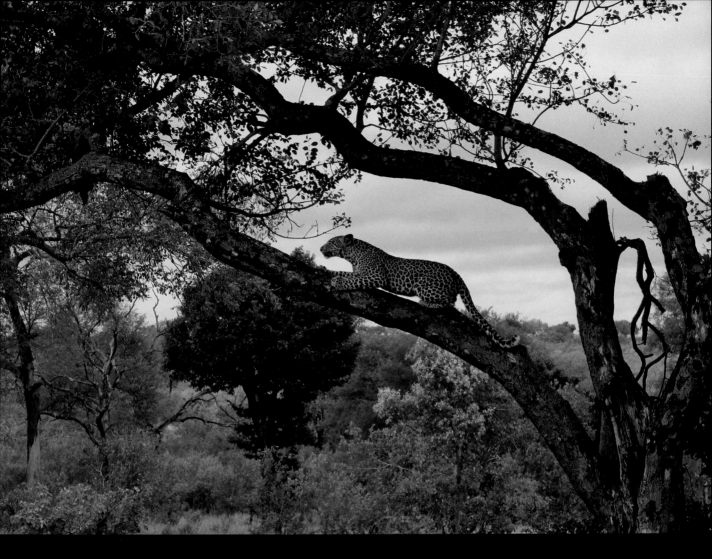

Crouching leopard

RUNNER-UP

Advaitesha Birla

INDIA

While on holiday in Kruger National Park, South Africa, Advaitesha was lucky enough to come close to her favourite animal. The leopard was not far from the jeep, and Advaitesha watched and photographed her for more than an hour. 'She moved slowly along the branch,' observes Advaitesha, 'almost as though she was looking for something, often keeping still for ages.' The leopard would sometimes look towards the jeep but didn't seem bothered by it. 'I took my picture of her crouching just as my battery was about to go flat and the jeep was about to leave,' she says. Later that day she met the leopard again, sharing a warthog carcass with what she had probably been searching for – her cub.

Wolf moment

SPECIALLY COMMENDED

Lasse Kurkela

FINLAND

Lasse is a keen naturalist and photographer, and the recipient of an environmental achievement award from his home town in Finland, and so the prospect of accompanying his father wolf-watching was hugely exciting. The location was a hide in the middle of a remote swamp area in Kuhmo, Finland, close to the Russian border. The trek there involved hiking through the swamp wearing thigh-length waders and carrying both equipment and provisions for several days. On their second evening, just a few minutes after his father had commented how the low September sunlight was perfect for photography, a male wolf walked into view. He paused just once to look around, which was the moment Lasse took his picture. 'Three nights was a long time to be in that hide,' says Lasse, 'but having got this picture made it all worthwhile.'

Nikon D800E + 300mm f2.8 lens + teleconverter TC-20E III; 1/500 sec at f8; ISO 4000; tripod + Markins ballhead + Wimberley Sidekick.

The stalker

SPECIALLY COMMENDED

Lasse Kurkela

FINLAND

Lasse was particularly excited to get this shot, which was taken from a hide
in a remote forest near Kajaani, Finland, about six hours drive from his home.
His father woke him at 4.30am that August morning to start watching for
wolverines. Lured by bait, a number had been around the hide all that night.
Now there were also ravens, sparrowhawks and magpies, and so no shortage of
subjects to photograph. But the most memorable moment was watching this
wolverine slowly stalking along a branch, intent on getting rid of the magpie.
'The bird turned its head just as I took this picture,' says Lasse, 'and gave me my
best-ever wolverine shot.'

**Nikon D800E + 300mm f2.8 lens; 1/1600 sec at f2.8 (+0.7 e/v); ISO 3600; tripod + Markins
ballhead + Wimberley Sidekick.**

Mother's little headful

WINNER (11-14 YEARS OLD)

Udayan Rao Pawar

INDIA
(SEE PAGE 140)

Catch of the day

RUNNER-UP

Sander Lødøen

NORWAY

About five white-tailed eagles live on the fjord, Valldal, southwestern
Norway, where Sander's family keeps a boat. One spring day, he set
off onto the water to photograph them. 'We were throwing fish out to
attract them,' says Sander. Finally one swooped into frame. Sander had
already decided on a slow shutter speed to capture the blur of action.
'The challenge', he says, 'was holding the camera steady on the boat
while following the eagle through the lens. I was so excited when I saw
the head was sharp and that I'd got the water splash.'

Nikon D700 + 70-200mm f2.8 lens; 1/20 sec at f11; ISO 400.

Poise

COMMENDED

Jef Pattyn

BELGIUM

Last winter was bitterly cold in the Netherlands, and after a heavy snowfall, a lot of blackbirds visited the fat feeders in Jef's garden in Oisterwijk. Setting up his hide, Jef started to try to photograph the birds flying in to feed. But the light was poor and it was tricky following them in flight. 'To compensate for the low light, I then concentrated on taking images using a slow shutter speed,' he says. After many attempts, he finally got his action shot, of a female blackbird. 'I was so engrossed getting her head sharp,' he adds, 'I didn't realise how cold I was.' A dynamic image bathed in soft low light was the reward for his pain and patience.

Canon EOS 7D + 100-400mm f4.5-5.6 lens; 1/60 sec at f6.3 (+1 e/v); ISO 500; Gitzo GT 3541LS tripod.

Still reflection

COMMENDED

Anton Lilja

SWEDEN

Anton and his father hired a hide for a day in Suomussalmi, Finland, hoping to see brown bears. They arrived at the hide in the evening, just as a storm whipped up. But by dawn, the pond in front of the hide was as still as glass, and the rain had stopped. They had put dog food on the other side of the water as bait, and they didn't have to wait long for a visitor. At 4.30am, a bear came out of the forest and stood right by the pond. 'I like bears a lot, and when I got the picture I wanted, in a really nice place, with the reflection, I was very happy,' says Anton.

Nikon D2X + 300mm f2.8 lens; 1/160 at f3.5 (-1 e/v); ISO 400.

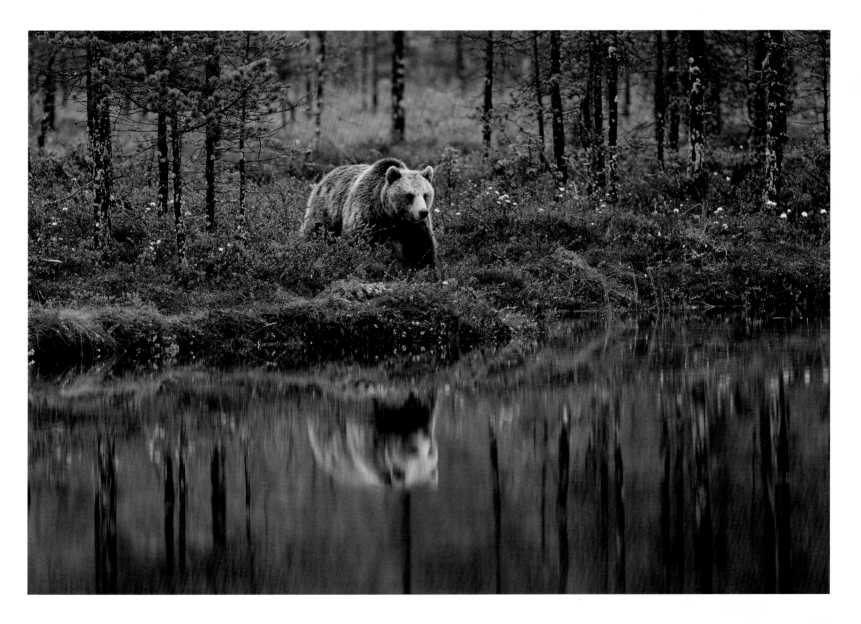

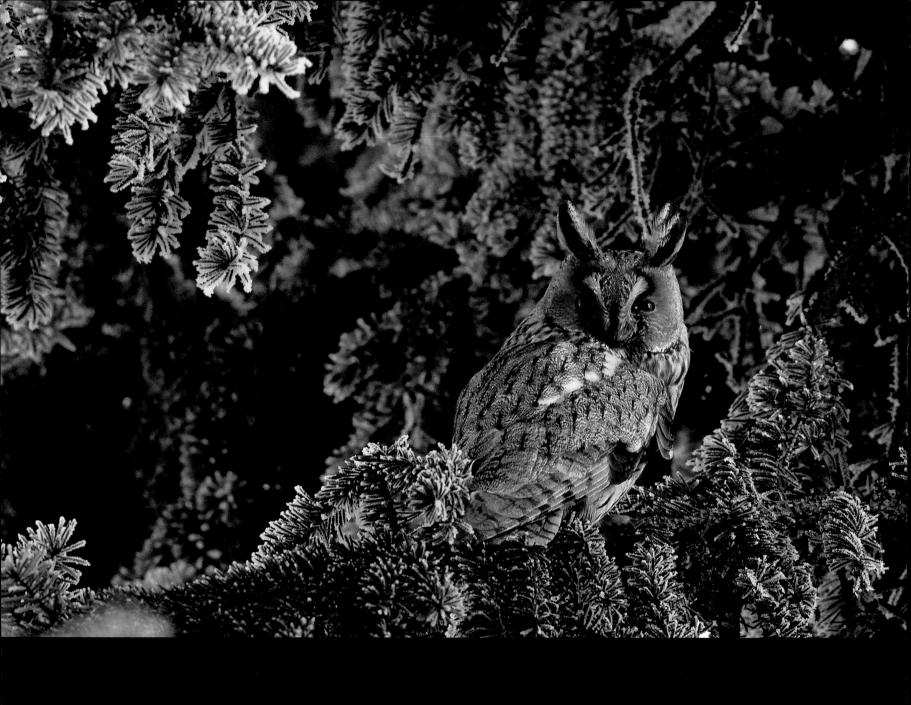

Last light

WINNER (15-17 YEARS OLD)

Mateusz Piesiak

POLAND

Not one but four strokes of luck helped Mateusz fulfil his dream of photographing a long-eared owl. He was out looking for owls in Lofer, Austria, one frosty winter evening when he saw a shape tucked into the branches of a spruce. As he approached, he realised that it was a long-eared owl. But it was too far within the tree to photograph. Then came his first stroke of luck: 'I then saw that there was a second owl nearby. It was roosting on an exposed branch, and I could see it clearly.' Mateusz was lucky in a second way, too, because the owl was dozing, and he was able to get very close. But it was so high up that the angle was wrong. Time for lucky stroke number three: 'I looked around and there, in exactly the right place, was a bench.' By balancing on the high back, he was able to frame the image he wanted. But there wasn't enough light. Then came stroke of luck number four: after 30 minutes, the clouds parted to release the last of the sun's rays. 'I got the photo you could only dream of,' the owl framed by the frost-encrusted tree, its soft plumage lit by the last of the evening light.

Canon 40D + 400mm f5.6 lens; 1/125 sec at 5.6 (-1 e/v); ISO 640.

Freeze frame

RUNNER-UP

Etienne Francey

SWITZERLAND

Etienne spotted this stoat, in its full winter colours, crossing a lane close to his home in Switzerland. It went into a snow-covered field at high speed and started jumping back and forth, presumably looking for signs of mice or rabbits. Etienne lay down in the snow and waited for it to reappear. When the stoat burst back into view about 10 metres away, Etienne had his camera ready. 'The stoat didn't seem to be spooked by me and continued jumping around,' he says. 'But it was a miracle that I managed to catch it in the air, at its highest point, and that I got it all in the frame, and in focus, too. I never expected to come home with such a picture.'

Nikon D7000 + 300mm f4 lens; 1/4000 sec at f4.5 (-0.7 e/v); ISO 400.

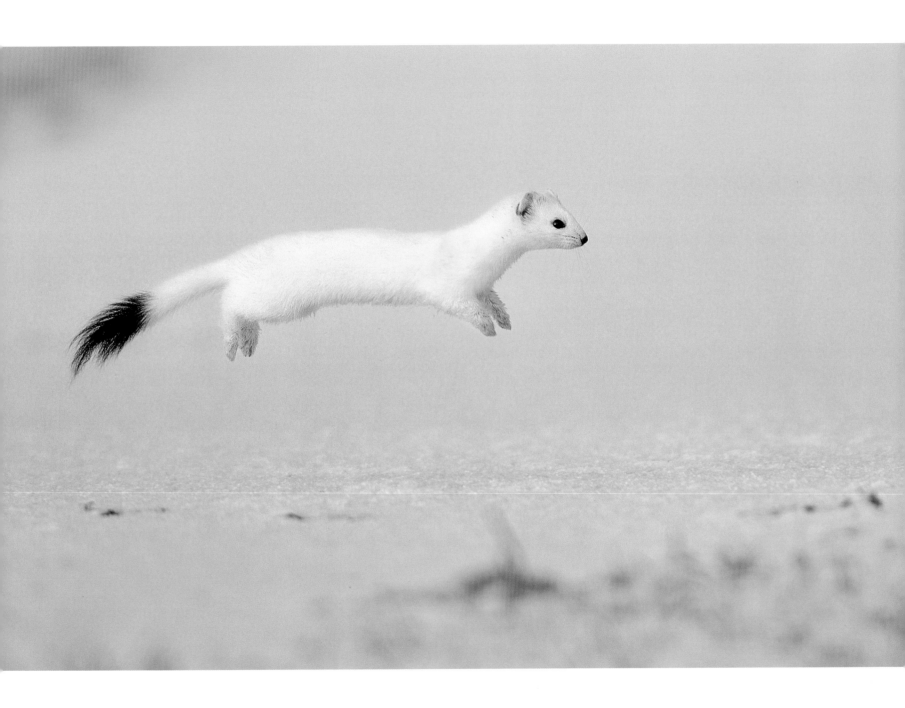

Harvest gold

COMMENDED

Etienne Francey

SWITZERLAND

Late one July evening, walking slowly along the edge of a wheat field near his village – Cousset, in Switzerland – looking for subjects to photograph, Etienne noticed 'a little ball' stuck to an ear of wheat. 'To my surprise,' says Etienne, 'it was a harvest mouse, nibbling the grain.' Etienne approached until he was a few metres away and managed to photograph the tiny mouse at various angles before it scuttled back down the wheat stalk. 'The meeting was brief but extraordinary,' he adds. 'This was my favourite out of all the portraits,' showing it eating, its prehensile tail helping it to balance.

Nikon D7000 + 300mm f4 lens; 1/320 sec at f4 (-0.3 e/v); ISO 500.

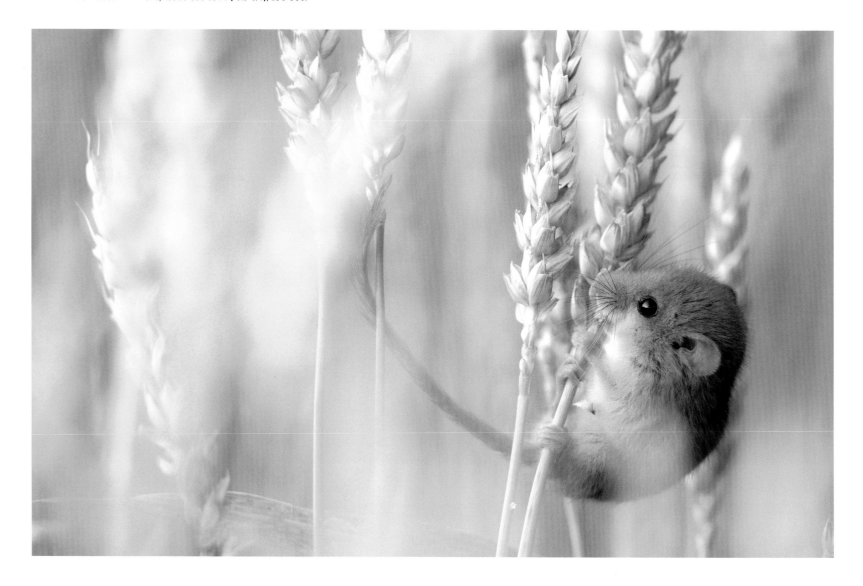

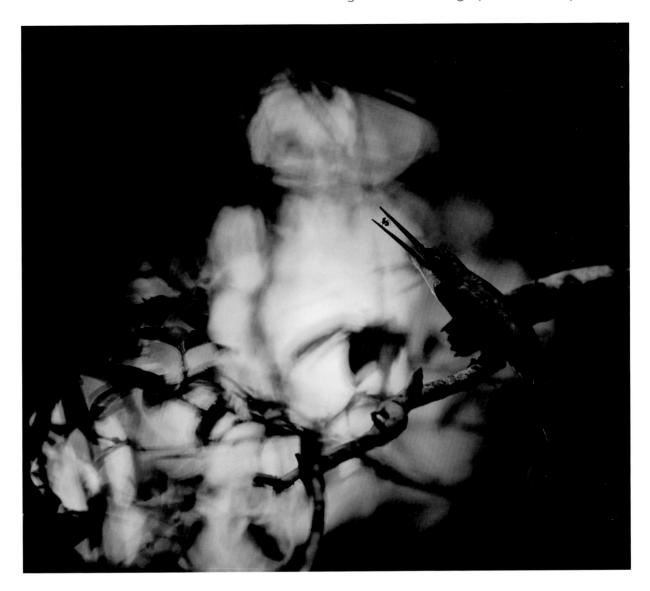

The juggling jacamar

SPECIALLY COMMENDED

Sander Broström

SWEDEN

Top of Sander's Trinidad and Tobago holiday wish-list was to photograph a rufous-tailed jacamar. These dazzling birds dig tunnels into the sides of mud-banks, where they rear their young. Sander searched in vain for them on Trinidad, but on Tobago, he found a pair nesting not far from his hotel. The jacamar parents were feeding their young. Even better, the site offered an interesting backdrop and a perch that they used before they went to the nest. 'Just once I saw the male rejig his prey in his beak before entering the nest hole,' says Sander. 'It was with great anticipation that I checked my camera and found that I'd managed to capture that split second.'

Canon EOS 7D + 300mm f2.8 lens; 1/8000 sec at f2.8; ISO 200.

Index of Photographers

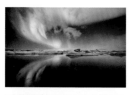

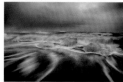

68, 73
Ellen Anon
USA
ellenanon@mac.com
http://ellenanon.com

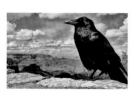

61
Chris Aydlett
USA
aydlettphoto@gmail.com
www.chrisaydlett.com

74
Olar Barndōk
ESTONIA
olar.barndok@gmail.com
http://olarbarndok.blogspot.com

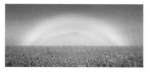

64
Stanislao Basileo
ITALY
stani20@inwind.it
www.stany.it

106
Alessandro Bee
ITALY
alessandrobee@hotmail.com
www.lightonthewild.com

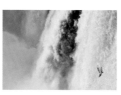

130-3
Daniel Beltrá
SPAIN/USA
danielbeltra@yahoo.com
www.danielbeltra.com

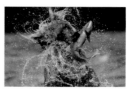

46
Valter Bernardeschi
ITALY
berna236@alice.it
www.ilmiocantolibero.com

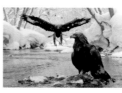

40
Alexey Bezrukov
RUSSIA
moonbear@rambler.ru
http://alexey-bezrukov.livejournal.com

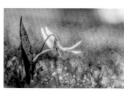

31
Valter Binotto
ITALY
binoval@alice.it
www.valterbinotto.it

143
Advaitesha Birla
INDIA
Agent
priyanka.khanna@adityabirla.com

54
Gergely Bíró
HUNGARY
geryb4@yahoo.com

90
Theo Bosboom
THE NETHERLANDS
info@theobosboom.nl
www.theobosboom.nl

108
Gregoire Bouguereau
FRANCE
contact@viemages.com
www.viemages.com

22
Łukasz Bożycki
POLAND
bozycki@gmail.com
www.bozycki.pl

155
Sander Broström
SWEDEN
sander.brostrom@gmail.com
www.sanderbrostrom.com

16
Peter Delaney
IRELAND/SOUTH AFRICA
delaneypeter@icloud.com
www.peterdelaney.co.za

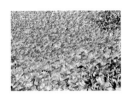

41
Yossi Eshbol
ISRAEL
yossi.eshbol@gmail.com
Agent
www.flpa-images.co.uk

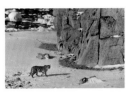

96
Toshiji Fukuda
JAPAN
ft48@snow.ucatv.ne.jp
http://fukuda.sakura.ne.jp

85
Thomas Haider
AUSTRIA
office@thomashaider.at
www.thomashaider.at
Agent
www.gettyimages.com

80
Jordi Chias Pujol
SPAIN
jordi@uwaterphoto.com
www.uwaterphoto.com
Agent
www.naturepl.com

88
Jasper Doest
THE NETHERLANDS
info@jasperdoest.com
www.jasperdoest.com

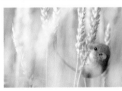

152, 154
Etienne Francey
SWITZERLAND
etienne.97@hotmail.com
www.chnature.ch

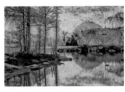

70
Adam Gibbs
UK/CANADA
adam_gibbs@shaw.ca
www.adamgibbs.com

34
Charlie Hamilton James
UK
www.charliehamiltonjames.com

48
Lou Coetzer
SOUTH AFRICA
lou@cnpsafaris.com
www.cnpsafaris.com

12-15
Greg du Toit
SOUTH AFRICA
greg@gregdutoit.com
www.gregdutoit.com

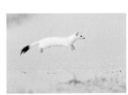

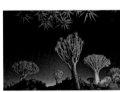

121
Justin Gilligan
AUSTRALIA
gilliganjustin@hotmail.com
www.justingilligan.com

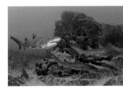

36, 62
Pål Hermansen
NORWAY
palhermansen@hotmail.com
www.palhermansen.com

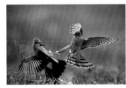

52
Julian Cohen
UK/AUSTRALIA
julian@juliancohen.com
www.juliancohen.com

28, 95
Uge Fuertes Sanz
SPAIN
chavaldelapetra@hotmail.com
http://ugefuertessanz.blogspot.com.es

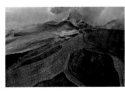

66
Sergey Gorshkov
RUSSIA
gsvl@mail.ru
www.gorshkov-photo.com
Agent
www.mindenpictures.com
www.naturepl.com

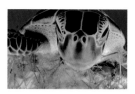

50
Luis Javier Sandoval
MEXICO
javier_uyuyuy@yahoo.com
http://seazoomdiving.com

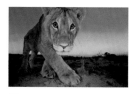

72
Gerard Leeuw
THE NETHERLANDS
gmjleeuw@hotmail.com
www.gerardleeuw.nl

18
Hannes Lochner
SOUTH AFRICA
hannes@lochnerphoto.com
www.hanneslochner.com

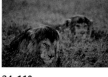

86
Bence Máté
HUNGARY
bence@matebence.hu
www.matebence.hu
Agent
Boglarka Somfalvi, boglarka@
matebence.hu

24, 110
**Michael 'Nick' Nichols/
National Geographic**
USA
nickngs@mac.com
http://michaelnicknichols.com
Agent
www.nationalgeographicstock.com

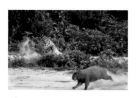

49
Zig Koch
BRAZIL
zig@zigkoch.com.br
www.zigkoch.com.br
Agent
www.naturezabrasileira.com.br
www.pulsarimagens.com.br

116
Garth Lenz
CANADA
garth@garthlenz.com
www.garthlenz.com

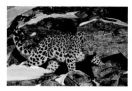

146
Sander Lødøen
NORWAY
sander__99@hotmail.com

101
Vladimir Medvedev
RUSSIAN FEDERATION
vladbear@mail.primorye.ru

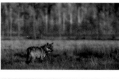

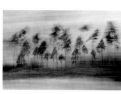

30
Jonathan Lhoir
BELGIUM
jonathanlhoir@hotmail.com
www.jonathanlhoir.com

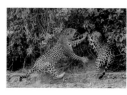

42
Joe McDonald
USA
joe@hoothollow.com
www.hoothollow.com

60
Per-Gunnar Ostby
NORWAY
pgo@pgoimages.com
www.pgoimages.com

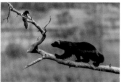

144, 145
Lasse Kurkela
FINLAND
lasse.kurkela@karpalo.net
http://lassekurkela.kuvat.fi

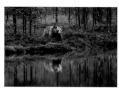

149
Anton Lilja
SWEDEN
antonlilja@live.se

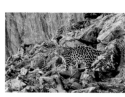

98
Valeriy Maleev
RUSSIA
valeriy@maleev.ru
www.maleev.ru

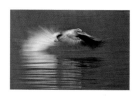

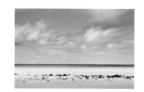

58
Alexander Mustard
UK
alex@amustard.com
www.amustard.com

56
Richard Packwood
UK
nantyr@btinternet.com
Agent
www.gettyimages.com

91
Agorastos Papatsanis
GREECE
agorastospap@yahoo.gr
www.agorastosphotography.com

150
Mateusz Piesiak
POLAND
matipiesiak@tlen.pl
www.mateuszpiesiak.pl

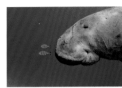

37
Steve Race
UK
steve.race@yorkshirecoastnature.co.uk
www.yorkshirecoastnature.co.uk

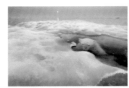

102
Paul Souders
USA
paul@worldfoto.com
www.worldfoto.com
Agent
www.corbisimages.com

142
Louis Pattyn
BELGIUM
louispattyn1@hotmail.com

32
Isak Pretorius
SOUTH AFRICA
isak@theafricanphotographer.com
www.theafricanphotographer.com
Agent
Siyenza Management
liz@siyenza.za.com

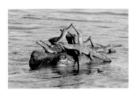

140
Udayan Rao Pawar
INDIA
udayanraopawar17@gmail.com

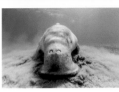

20, 84, 120
Douglas Seifert
USA
info@douglasunderwater.com
http://douglasunderwater.com

148
Jef Pattyn
BELGIUM
jefpattyn@hotmail.com
www.jppictures.com

55
Alejandro Prieto
MEXICO
alejandro_prieto@yahoo.com.mx
www.alejandroprietophotography.com

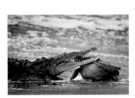

100
Diana Rebman
USA
dianarebman@aol.com
http://dianarebmanphotography.com

76
Brian Skerry
USA
brian@brianskerry.com
www.BrianSkerry.com
Agent
www.nationalgeographicstock.com

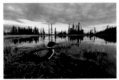

118
Thomas P Peschak
GERMANY/SOUTH AFRICA
thomas@thomaspeschak.com
www.thomaspeschak.com

112
Arto Raappana
FINLAND
arto.raappana@gmail.com
www.artoraappana.fi

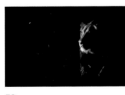

59
Andrew Schoeman
SOUTH AFRICA
a.nschoeman@gmail.com
www.andrewschoemanphotography.co.za

65
Marcos Sobral
PORTUGAL
marcos_photography@hotmail.com
www.lisboameninadourada.blogspot.pt

134-9
Connor Stefanison
CANADA
connor_stef@hotmail.com
www.connorstefanison.com

23
Marc Steichen
LUXEMBOURG
photo@marcsteichen.com
www.marcsteichen.com

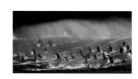

122-9
Brent Stirton
SOUTH AFRICA
brentstirton@gmail.com
www.brentstirton.com
Agent
www.gettyimages.com

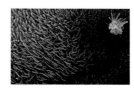

78
Alex Tattersall
UK
alex@uwvisions.com
www.uwvisions.com

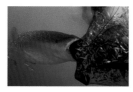

104
Wim van den Heever
SOUTH AFRICA
wim.vandenheever@gmail.com
www.wimvandenheever.com

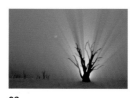

92
Marsel van Oosten
THE NETHERLANDS
marsel@squiver.com
www.squiver.com

26
Kalyan Varma
INDIA
kalyan@rtns.org
http://kalyanvarma.com

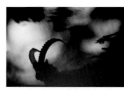

114
Mike Veitch
CANADA
bigblueimages@yahoo.ca
www.mikeveitchblog.com

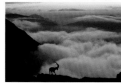

94, 107
Jérémie Villet
FRANCE
contact@jeremievillet.com
www.jeremievillet.com

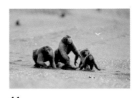

44
Andrew Walmsley
UK
awalmsley82@gmail.com
www.andrewwalmsleyphotography.
com

82
Solvin Zankl
GERMANY
szankl@aol.com
www.solvinzankl.com
Agent
www.naturepl.com

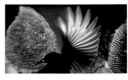

38
Ritzel Zoltán
HUNGARY
zoltan.ritzel@gmail.com